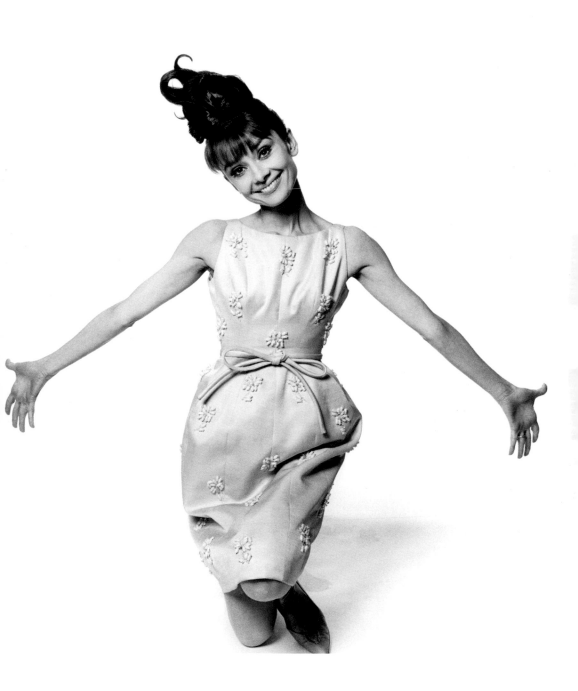

VOGUE ON

HUBERT DE GIVENCHY

Drusilla Beyfus

Quadrille
PUBLISHING

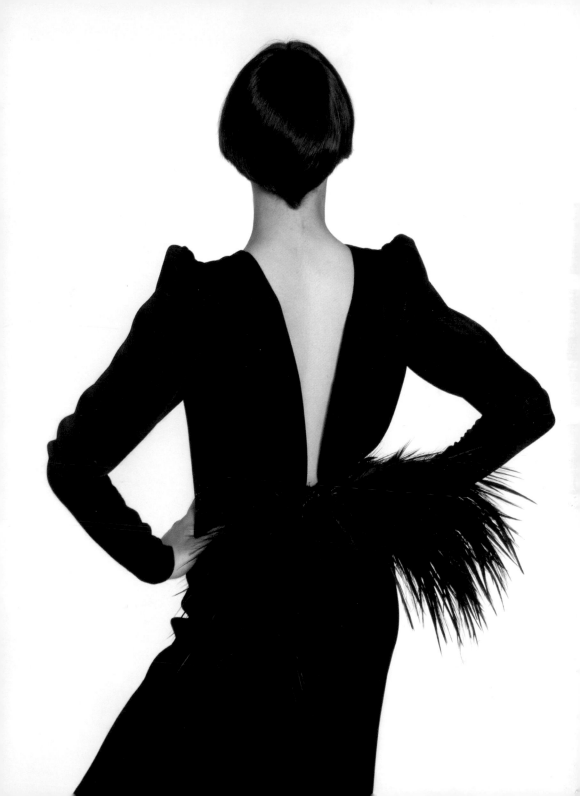

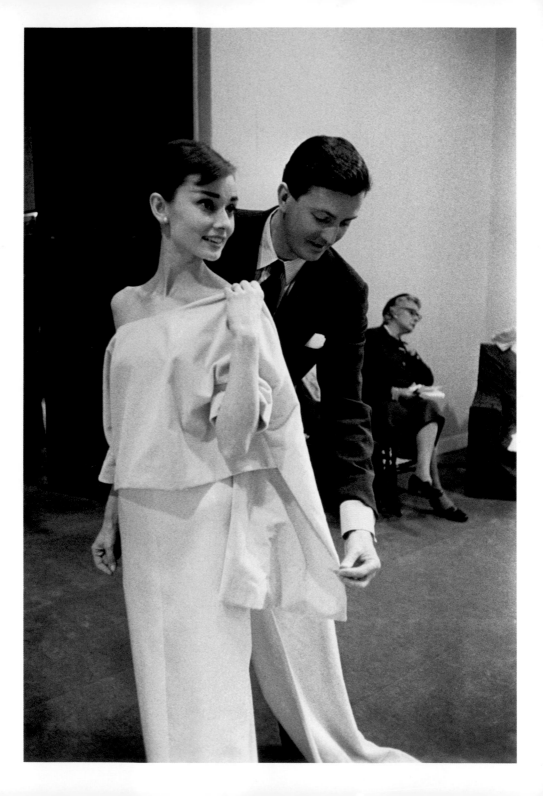

Audrey Hepburn with Hubert de Givenchy on the set of the movie Funny Face. *Photograph by David Seymour, 1956.*

page 1 *Audrey Hepburn shows off Givenchy's short dinner dress of yellow silk, embroidered in mother of pearl and crystal. 'Shaped by informed cutting,' says Vogue, 'that gives a delicious roundness to the skirt.' Photograph by Bert Stern, 1963.*

previous page *'Fitting black satin straight to the floor, plume of black feathers,' writes Vogue on this little black dress by Givenchy. Photograph by Bruce Weber, 1982.*

'A BRILLIANT HAND WITH SEPARATES.'

VOGUE

BIRTH OF A COUTURIER

When, as a young man, Hubert de Givenchy was invited to grand dances, he sat out because he didn't dance. He has said he spent the time 'looking'. There was much to catch his eye. The newly optimistic mood in Paris that followed the Liberation in the late 1940s heralded a flurry of balls, tactfully held in aid of war charities. *Vogue Paris* published in colour the Bal des Oiseaux at the Palais Rose in November 1948, the writer extolling the shimmering tones and glints of the tropical theme in a winter season. Pyramids of flowers and gilded branches decorated the ballroom, birds taken from their glass domes, perched like jewels on arboreal resting places. Among titled members of old French families could be seen Elsa Schiaparelli, her headdress and fingernails in Shocking Pink, the dancer and singer Josephine Baker wrapped in a feather boa and the artist Christian 'Bébé' Bérard. Prince Jean-Louis de Faucigny-Lucinge wrote of the period, 'Never, since the Age of Enlightenment has society found itself so close to artists.' Guests proceeded up the great staircase of pink and grey marble to the reception rooms, admiring each other's feathered masks, fans and headdresses. Among the photographed guests was Hubert de Givenchy.

Hubert de Givenchy at the studio of his first salon, rue Alfred de Vigny, Paris, in the early Fifties. He is perfecting the shirring (gathers) on a work in progress, modelled in house.

The young Frenchman, born 1927, was the scion of an aristocratic family of practising Protestants in northern France. A distinguishing physical characteristic was his great height, standing at 6 feet 6 inches. Handsome and said to be rather shy, he had a courteous demeanour. At the ball he can be seen as extending his apprenticeship in his chosen vocation, haute couture. His interest in women's fashion and fabrics had roots in childhood curiosity, and was to lead to a forty-year pursuit of what he deemed 'the most beautiful metier' and his becoming one of the outstanding masters among a generation of couturiers that dominated fashion in Paris after the Second World War.

A long view of Givenchy in the pages of *Vogue* shows how much dress design owes him. His work carries on the historic traditions of haute couture as practised by his mentor and idol, Cristóbal Balenciaga, the Spanish master.

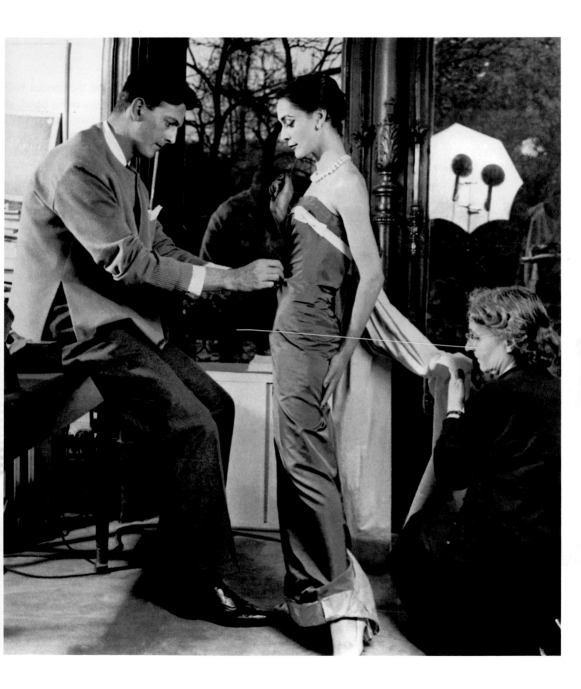

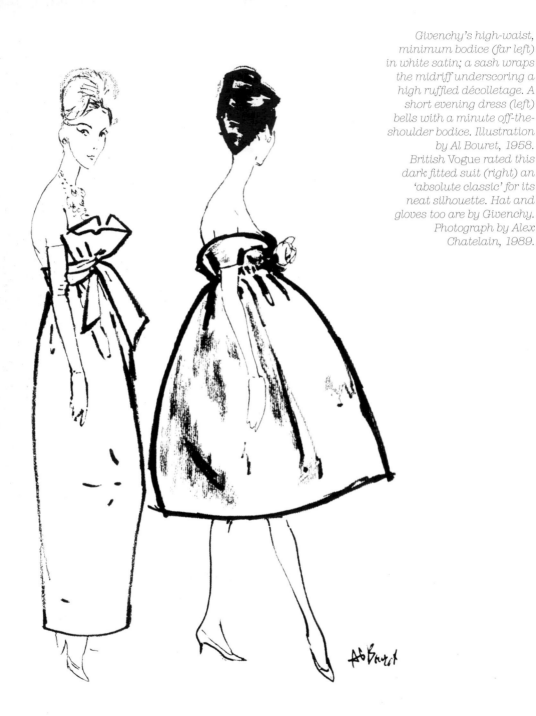

Givenchy's high-waist, minimum bodice (far left) in white satin; a sash wraps the midriff underscoring a high ruffled décolletage. A short evening dress (left) bells with a minute off-the-shoulder bodice. Illustration by Al Bouret, 1958. British Vogue rated this dark fitted suit (right) an 'absolute classic' for its neat silhouette. Hat and gloves too are by Givenchy. Photograph by Alex Chatelain, 1989.

'IN "BREAKFAST AT TIFFANY'S" HUBERT DE GIVENCHY'S ICONIC BLACK DRESS FOR AUDREY HEPBURN HAS ENTERED FASHION HISTORY.'

VICTORIA & ALBERT MUSEUM
HOLLYWOOD COSTUME, 2012

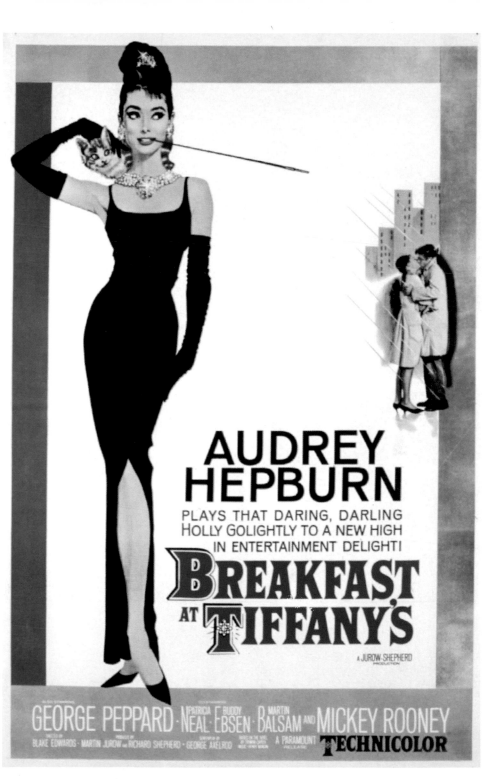

To Susan Train, *Vogue*'s American editor in Paris, Givenchy came to 'personify not only the continuity of post-Second-World-War haute couture, but also links with the traditional pre-war couture.' He may not have moved the tectonic plates of fashion, but there's a strong case for recognising his creative consistency in a period of almost wanton stylistic change. Always the perfectionist, his style is hard to define, as the classicism that was his bent breaks out from time to time into playfulness, fantasy and surprise. Women have to thank him for the emphasis on comfort, a significant consideration since he worked at a time when Paris couture still cast a kindly eye on the corset and tight bodice. Fabrics he regarded with the scrutiny of an artist, seeing them as primary inspiration for forward thinking. Unusual materials inspired him, as did innovative combination of textures and types. He also helped develop the application of synthetics such as Lurex and Orlon. Above all, he intuited the female sartorial psyche. He really did know what women want. 'A Givenchy coat would be most women's ideal of the perfect way to look in daytime,' commented British *Vogue* in 1960. It could have been said a thousand times in *Vogue*'s coverage of the designer, whatever the intended hour of the piece.

'French cut string bean,' was how American Vogue *viewed Givenchy's black jersey dinner sheath. It possessed, 'no collar, no back, no nothing but terrific shape.' Photograph by John Rawlings, 1953.*

previous page A poster of Audrey Hepburn in Givenchy's emblematic black sheath for her character as Holly Golightly in Breakfast at Tiffany's, *1961. Directed by Blake Edwards, the film is based on a story by Truman Capote. Audrey has said 'Clothes have given me the confidence I often needed.'*

Also due to his hand are some supremely stylish moments in modern dress in film production. Hubert de Givenchy and Audrey Hepburn met in connection with the costumes she was to wear in one of her Hollywood movies, an encounter that ricocheted across the boundaries of fashion and show business. In the process, Givenchy's designs (but not Givenchy himself) won an Oscar and the leading lady became his muse, friend and the personification of his style. To name but one of his sartorial hits in Hepburn's films, who can forget Holly Golightly's Little Black Dress in the opening shots of *Breakfast at Tiffany's*? It's a model of the form.

'Sometimes a single millimetre
is all it takes.'

CATHERINE JOIN-DIÉTERLE

Givenchy has said that to dress a woman is to enhance her beauty, and I questioned him on the matter in an interview. 'Trying to make a woman more beautiful is to try to understand her well, for her to be well dressed and above all, comfortable in her clothes. If a woman moves well, her gestures will be natural and she will be happy,' he commented. 'Clothes can change many things in the life of a woman. Many of my clients have told me that when they met the man of their life, they wore a little plain Givenchy dress and it helped them conquer their future husband. Perhaps this is a compliment that these clients and friends wanted to pay me, but I also know that there is some real evidence for this testimony.'

British Vogue *liked the 'pared down minimum' of Givenchy's couture day dress, shown in oatmeal tweed. With its tailored fit, a small tongue of a collar and solo button the design is recognised as one of his best. Its long, lean look is accompanied by a plumb straight hat in beige leather and white cuffed gloves. Photograph by Henry Clarke, 1955.*

It has also has to be said that a little plain Givenchy dress conceals the intense craftsmanship that goes into its magic. Here is an account of a model that the imagined client or friend might have been wearing. British *Vogue* and *Vogue Paris* in September 1955 gave a full page to a shot by Henry Clarke of the couturier's 'Long, Lean Dress'. It was captioned, 'Superbly detailed arrow-slim interpretation of the pared down minimum, collarless, short sleeved, his oatmeal tweed dress has a semi-fitted diagonally seamed waistline, is high-necked, flat in front.' What may also have had a bearing on the case of the aforesaid smitten spectator is the creator's observation that 'In haute couture we are cosmetic surgeons, erasing imperfections and refining the silhouette.'

When people reference Givenchy today it tends to be in classical terms. He didn't do sartorial bombshells, avoided street style and wasn't tempted by the raunchy. However, we can see him as the precursor of that most contemporary phenomenon, the entrepreneur designer who is the brand. *Vogue* portrays his house style as elegant, refined and cultured – qualities that others have recognised in the man. As a couturier and in private life he inhabited the realms of high fashion, high art and high society, all of which come to mind in connection with his label. He acted as his own ambassador, using his strengths. It's not disrespectful to say that few of his compatriot designers would fit the description accorded him in American *Vogue*

in the mid-sixties as being 'handsomer than almost any movie star'. *Vogue* has seen him as couturier, costume designer, interior decorator, art connoisseur, fashion model, perfumery and cosmetic producer, company director and, also, as a member of fashionable society. His country houses and private Paris domain as well as his art collections attest to the joined-up nature of his aesthetic. And it goes without saying that whatever the public event or occasion or location at which he appeared, he was perfectly dressed for it.

The launch of the House of Givenchy on 2nd February 1952 at 8, rue Alfred de Vigny, an 1860 Gothic building near Parc Monceau, marked the beginning of *Vogue*'s empathetic and consistent coverage of the designer. Opening to a jubilant if chaotic reception, it channelled innovation. How very different the atmosphere must have been from that at the great reigning houses. There, the wonder of the designs, the spectacle of unimagined colour combinations, the original fabrics, the unexampled luxe of everything was theatre. But it was not young in heart. At the age of 24 Givenchy was set to go. As *directrice* he secured Mme Hélène Bouilloux-Lafont, a life-long friend who helped raise the necessary loan to open his *maison de couture*. The company started with a team of fifteen employees, and engaged some of the prettiest fashion models in Paris for the launch collection. Three of these beauteous professionals were Capucine, Suzy Parker and Bettina Graziani.

Italian fashion illustrator René Gruau's retrospective drawing of The Bettina blouse, named after the model who showed it at Givenchy's launch collection. Bettina Graziani attracted the eye of the Press in a design made – most unusually in Paris couture – of low-status cotton shirting. The sleeves burst into double ruffles embroidered in black eyelets.

'I had a vision of fashion that was more convenient, easier and different – the Separates,' he told me. The point, in his words, was 'to make getting dressed an easier choice.' British *Vogue* explained that the young Frenchman had taken the unusual course of launching on the strength of a boutique collection, at which he had displayed a 'brilliant hand with Separates.' American *Vogue* noted, 'The applause at his premiere was loud, unqualified and long.' It liked the way the couturier had catered to the young Frenchwoman who wanted to combine high fashion with low prices. Among the early visitors to the salon was Jacqueline Bouvier, then a Sorbonne student,

later to become America's First Lady as the wife of John Kennedy. Her preference for French fashion in that role famously caused an outcry in the US media.

Separates were done largely in two tones, black and/or white. A strapless bodice could be worn with a skirt or narrow trousers, the little jacket would go well with the skirt or the trousers. British *Vogue* selected the beautiful white blouses with a 'laundered' look as key to the season. One achieved prominence as The Bettina, named after the model, who also worked as the designer's right-hand assistant and did his public relations. Made in cotton shirting primarily for reasons of economy – there wasn't much money for costly fabrics – the blouse was extremely feminine and decorative: close cuffed, its long sleeves burst into double ruffles embroidered in black eyelets. Capucine's white organdie décolleté, tucked with faux white flowers made one of the key photographs. At the show, American *Vogue* fashion illustrator Eric (Carl Erickson) was charmed by a bare-shoulder ball dress of grey starched chiffon belted with peony red ribbon. In noting the showstopper, the caption read, 'when the woman turns round the dress vanishes into a great tiered cape that's made, surprisingly, of white percale.'

Vogue artist Eric uses colour to realise a romantic evening dress and cape shown at Givenchy's debut collection, 1952. Eric's brushstrokes catch its feminine mood and surprising contrasts.

'The most important fashion editors both French and American swooped upon the young house and carried the name of Givenchy to fame whilst simultaneously creating a pandemonium of conflicting ideas and advice,' recalled Susan Train. 'Elegant clients vying to buy this new young fashion look besieged him with their own demands: the dressmaker dummies were stripped, the fledging business faltered. There were not enough qualified workers nor ateliers to produce quickly enough … He was urged to return to the concept of a traditional couture house.'

'Fabric is alive. I let the fabrics guide me.'

HUBERT DE GIVENCHY

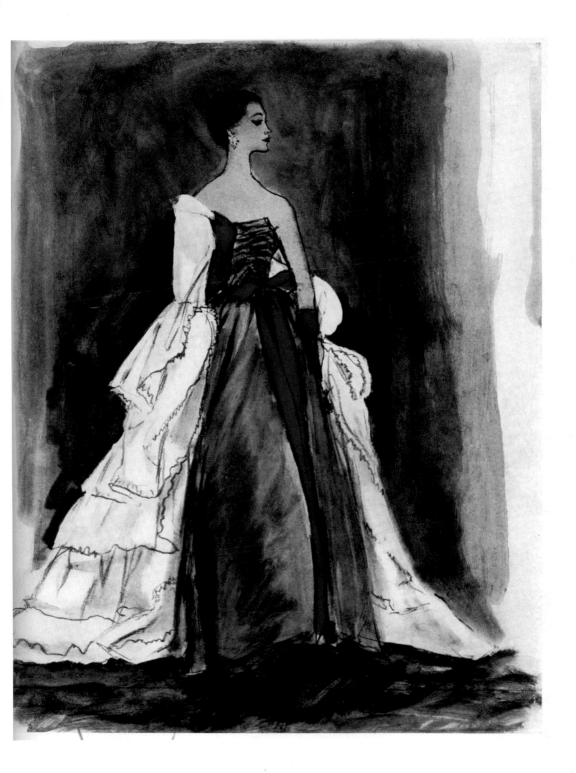

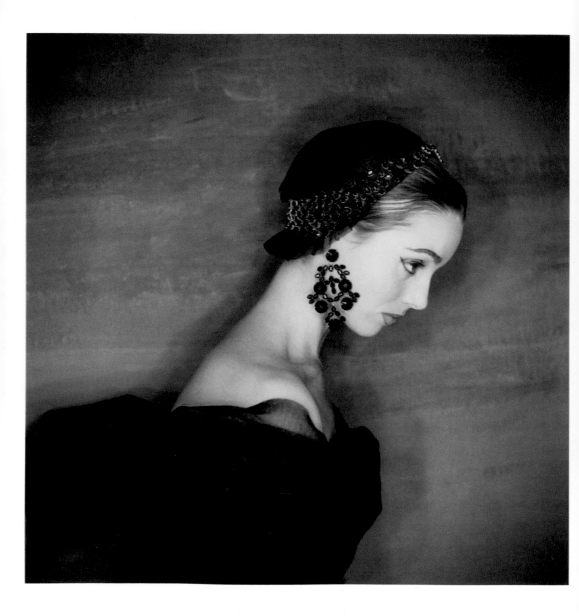

'THAT FANTASTIC
BALANCE OF
ABSURDITY, GENIUS,
AND LOVE MAKES
A GIVENCHY
HAT ONE OF THE
ENTRANCEMENTS
OF LIFE.'

VOGUE

In the following collections and beyond, Separates stayed central to the picture. Much else sustained his innovative stance: for example, a close-fitting cap that concealed the hair and revealed the face was said to demand 'a new approach to grooming'. British *Vogue* reminded its readers to 'resist the Englishwoman's impulse to pull out a softening wisp of hair.' In general, Givenchy's ideas on the hat were regarded as one of his strengths and a contribution to female happiness. The response to his collections continued to be positive and in 1959 the salon moved from what had been a modest off-centre address to avenue George V.

B ritish *Vogue*, in its first write-ups, noted that the fledging couturier was, in practice, quite seasoned. In fact, his induction into the world of fashion and art had begun with his family. The younger son of Lucien, Marquis de Givenchy, and the former Beatrice 'Sissie' Badin, Hubert de Givenchy grew up in an artistically minded, haute bourgeois environment. When Hubert was two years old, his father died of influenza and he and his brother Jean-Claude were brought up by their mother and maternal grandparents at Beauvais, north of Paris. Grandfather Jules Badin had become head of the Gobelins and Beauvais tapestry workshops, having started out as an artist. He was a collector of rare textiles and objets d'art and is thought to have awakened young Hubert's ambitions. In addition, in a memoir in *Vogue Paris*, Givenchy writes of his recollections of his mother's delight in fashion. According to the history books, a creative atmosphere flourished as cousins, uncles and aunts turned to music and drawing. In the nineteenth century, three of Givenchy's ancestors had become well known in contemporary artistic circles.

Givenchy's precocity in the field of fashion is well documented. At the age of about eight he made dresses on dolls in the manner of the wardrobes of the elegant women he noticed in his mother's fashion magazines. As a ten year old, he visited the 1937 Paris International Exhibition where he was enthralled by the Pavilion d'Elegance under the presidency of Jeanne Lanvin. 'In a perfumed grotto of pink plaster,

previous page British Vogue *identified* the hat of the season as 'the hair concealing hat' saying, 'the tulle helmet, frilled, all back-drawn, soft and covering the hair, is typical of Givenchy's close fitting little caps.' Photograph by Clifford Coffin, 1954.

Paris couture had created a world of caprice [fashion historian Robert Riley was later to write]; stylized mannequins wore stylized clothes in a great game of make-believe ... Chanel's two mannequins in enormous ballet skirts of iridescent tulle, Schiaparelli's mannequin lolled nude on a bed of flowers, her discarded dress and hat thrown conveniently over a garden chair.' Dresses by Vionnet, Grès, Molyneux and by Jeanne Lanvin herself added to the spectacle. Givenchy came away resolved to join them one day. Predictably perhaps, his conservatively minded family were not best pleased by this direction and expected him to go into one of the senior professions. When the time came for his future to be decided he was placed in a notary's office after which the family insisted on his attending law school. His mother's eventual reconciliation with his intentions was on the understanding that never should he complain or change his mind.

First stop for a job was at Cristóbal Balenciaga, the Spanish master couturier. The aspiring designer wanted to show him some drawings with a view to becoming his assistant. 'As a child I was already admiring Balenciaga,' Givenchy told me. 'The elegance and beauty of his clothes and shapes were very different from other designers.' Balenciaga was the unsurpassed artist in his practice, a gold standard in haute couture, and was to become the young Frenchman's mentor, teacher and friend. However, on this initial occasion he was turned away at the door by the salon's formidable *directrice*, Mademoiselle Renée.

'Mr Balenciaga combined creative genius,
a flair for the avant-garde, and a technique
that has remained unsurpassed.
He was the complete creator.'

HUBERT DE GIVENCHY

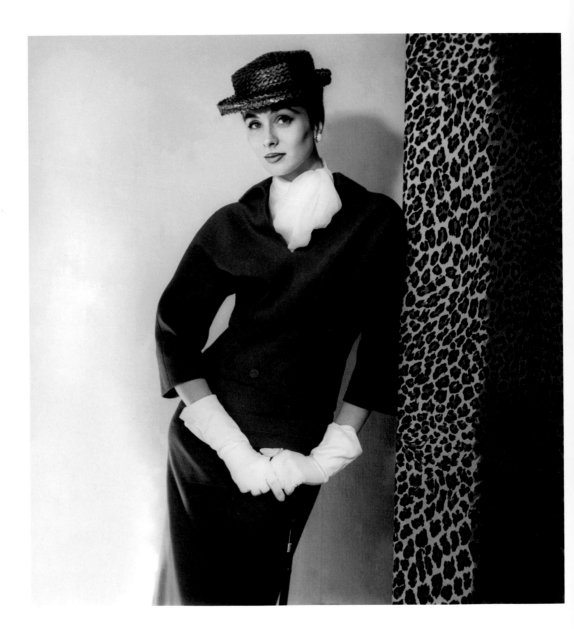

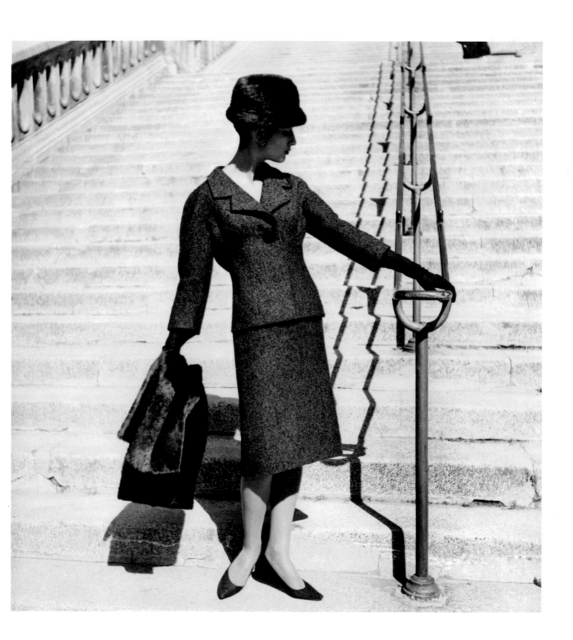

Calling at Jacques Fath, then the most fashionable house in Paris, the couturier signed him up immediately. Fath was known for producing young and sexy clothes within the conventions of couture and some have seen that Givenchy's more high-spirited ideas bear Fath's long-term mark. The designer found Fath 'A strikingly handsome man, quite different from anyone else; he was wearing grey flannel jodhpurs and a cashmere pullover under a voluminous wolf fur coat. I was very fortunate in meeting Fath. Without him I would never have been able to get started in fashion, for it was almost impossible to find a job in couture in those days. His fashion house was a haven of fun and fantasy … the atmosphere completely captivated me. Entering Jacques Fath's fashion house was like stepping into a universe of danger and sensuality.' During his one year at the salon in 1945 Givenchy also attended classes at the Ecole des Beaux Arts to improve his drawing. Evidence suggests the tuition was effective. His fashion sketches convey in shorthand form the essence of a design, the little figures having a fillip of humour in the poses and attitudes struck.

In between his time at Fath and opening his own salon, he moved first to Robert Piguet and then briefly to Lucien Lelong to explore other ways of working, a journey which culminated in a four-year stay with the Italian designer Elsa Schiaparelli. Creatively free, he breathed excitement into her Place Vendôme boutique and in the process was introduced to many of Schiaparelli's prominent clients. It has been said that during these formative years he met 'Le Tout Paris'. The young designer's reputation was already such that after Schiap closed in 1954 several of her private clients and friends turned to his salon, among them Marlene Dietrich, Patricia Lopez-Willshaw, Gloria Guinness and the Duchess of Windsor. On the death of the Duke of Windsor in 1972 Givenchy created and made overnight a black coat for the Duchess.

It was under Schiaparelli's roof that he conceived many of the ideas shown at his launch collection. Separates were a precursor to an allied concept. 'I had the idea of luxury ready-to-wear' he told

me, explaining that he had thought of the former in the light of the latter. Designer-led ready-mades were to sprinkle the fairy dust of Paris fashion over top-end boutiques and leading dress departments on both sides of the Atlantic. *Vogue* was ready for the change. 'There's been a quiet revolution going on in French fashion,' said the British edition in 1956. 'The traditional supremacy of the couturier and the little dressmaker has been brilliantly challenged by a growing, thriving ready-to-wear industry.'

Givenchy's first attempt at a formal launch of a ready-to-wear collection had failed. Copies of his designs by well-known dress manufacturers were featured in British *Vogue* in the late Fifties but the production system had been inefficient; however, his next try took off.

Givenchy Nouvelle Boutique, opened at 66, avenue Victor Hugo in March 1968. He was one of the first Paris haute couturiers to back the belief that luxury ready-to-wear was the future, as indeed it proved to be. The concept was the forerunner of the powerful prêt-à-porter collections, the latter stimulating a big increase in the wider field of ready-to-wear. The Givenchy Nouvelle Boutique collection was big news in the three national editions of *Vogue*. It brought word of an accessible line inspired by the designer's haute couture collection – that is, the previous one – and selling at considerably lower than couture prices.

Givenchy's boutiques commanded his personal attention. American *Vogue* photographed the couturier at his Bergdorf Goodman salon, greeting a customer. *Vogue Paris* published a story on his first much-awaited stand-alone boutique on Madison Avenue, which opened in 1985. The couturier poses for shots outside the store windows, an arm round the shoulders of a model styled in a chiffon print from the new collection. The story explains that the whole boutique idea was based on Givenchy's belief that there was a need to assist customers in achieving a total look. It was not unusual to see him in his Madison Avenue boutique, 'straightening a hat, recreating a seasonal ambiance,' readers hear.

The Nouvelle Boutique collection was younger in mood than the couture collection and astutely conceived with the way of life of the potential wearer in mind. Coat and trouser looks, tunic and trouser combinations, skirt and shirt turn-outs and lots of sweater dressing took the floor. In American *Vogue* Hollywood film actors such as Marisa Berenson modelled the designs. Berenson, Elsa Schiaparelli's grand-daughter, adds glamour to a midi length khaki-coloured raincoat, caped to the hip, double breasted and belted, made in cotton and polyester. The photographer is her sister, Berry Berenson. The magazine also featured from the line a denim button-through which shows what a designer can do with a garment that often passes as an overall. In navy denim, printed with a pale-brick-coloured Paisley motif, it was collarless, narrowly belted, made with long cuffed sleeves and had slits for pockets at the hip. Accounted the 'blue denim dress that everyone wants this summer,' it gains extra dash from the fact that the skirt is unbuttoned in the photograph as far as decency rather than decorum would allow.

From the Nouvelle Boutique collection the British edition selected a design with a lot of use in it, one of the 'new black and white linens, high-waisted with tiny cap sleeves, a brief bodice buttoning over a slightly gathered skirt.' *Vogue Paris* marked the launch with a youthful culottes dress in bluebell jersey, sleeveless, belted, and worn with dark-toned mesh tights.

In bands of rainbow colour, a characteristic Givenchy silhouette done in four tiers – funnel collar, bodice, midriff and skirt. Photograph by Clive Arrowsmith, British Vogue, 1970.

previous pages Eight of Givenchy's fashion sketches from the Fifties. Done in pencil, these light-hearted illustrations were given to the heads of the studios for practical guidance.

'The secret of elegance is to look like oneself.'

HUBERT DE GIVENCHY

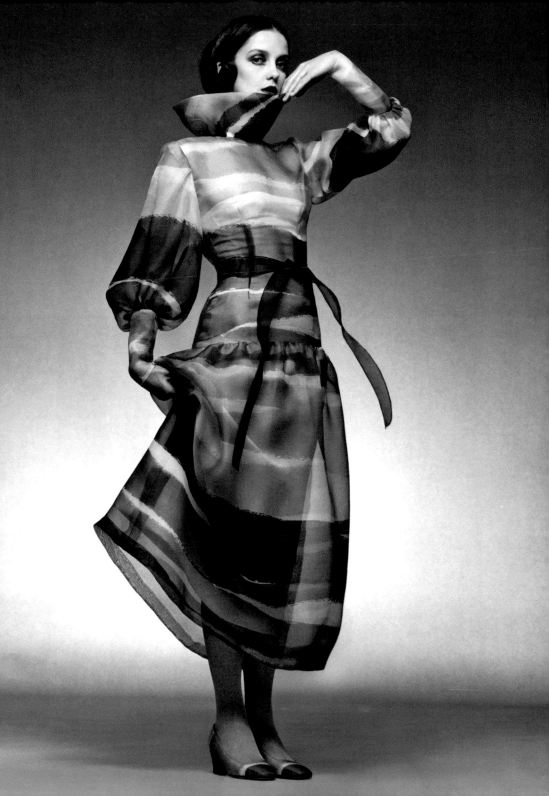

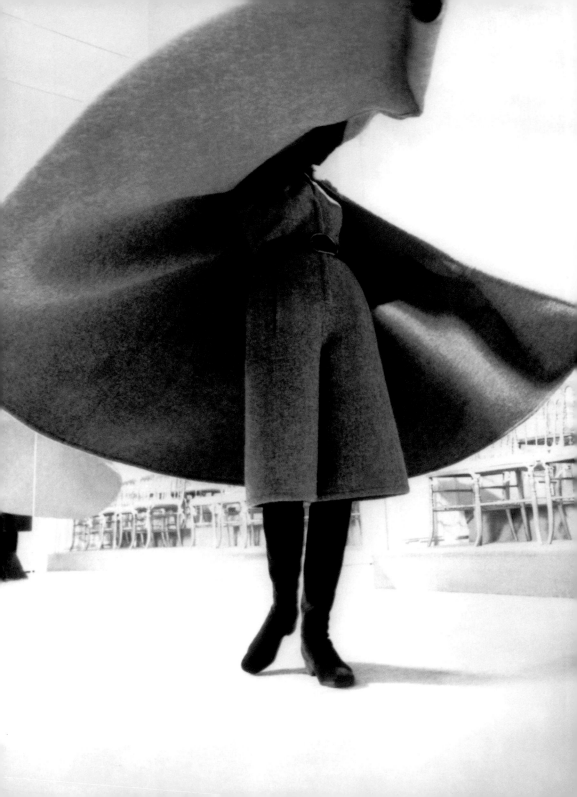

'GIVENCHY HELD TRUE TO HIS OWN STANDARDS OF SOPHISTICATED ELEGANCE AND A TOTALLY POLISHED, TURNED-OUT STYLE OF DRESSING.'

SUSAN TRAIN

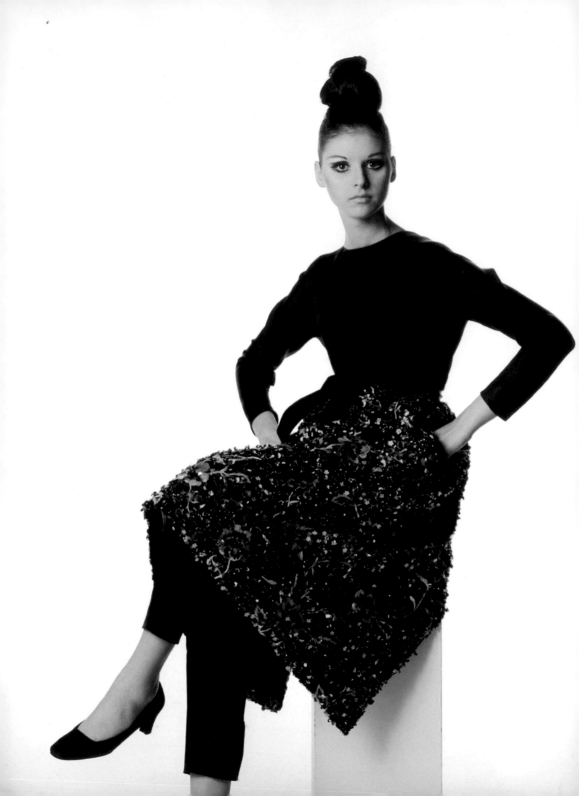

Contemporaneous with the expansion of ready-to-wear, the main collections remained unruffled and got on with their business of doing ultimate luxuriousness in the modern manner. In 1968 American *Vogue* singled out, 'a black satin jumpsuit, a long sleekness with a ravishing jewel-sparkled apron, black satin embroidered with red roses, green leaves re-encrusted with red, green, and black sequins.' Photographed by Irving Penn, it proved one of the hits of the autumn season.

By the Sixties, it's fair to single out Givenchy's singing success in the United States, his collections offering a complete look and fitting in with an American respect for clothes that were, as a writer put it, 'un-fidgety' and straightforward. Over seventy per cent of his couture clients were said to be North American. 'It is just as well that we have the Americans and the Italians,' he once said drily, 'French women are so much more classic.' The Americans had appreciated his imagination from the start, he said. In their turn, as was made plain in due course, the Americans valued a seriousness about him. At the Fashion Institute of Technology's 'Givenchy Thirty Years' retrospective in New York, they talked of a connection between the new world that came into being after the Second World War, when redefinitions of the individual within society were being sought in Europe, and the designer's 'discipline, restraint and rigour'. Bearing in mind that diplomatic relations between the host country and France were not of the warmest at the time, it was a compliment to the designer to be told that his work 'identifies, clarifies and even validates the vitality of the French tradition.' Robert Riley who writes the main text in the catalogue stresses that Givenchy has both the historical background and a sensitivity to his time. Givenchy's remark is quoted: 'I am a traditionalist and very glad to be alive today'.

'Newest thing in pants, the one-piece jumpsuit,' said American Vogue *in 1968. 'A long, racy line from throat to ankle that raced through the Paris collections.' Givenchy's ideas on it, as worn with an embroidered and jewelled apron, are photographed by Irving Penn.*

previous page *Opened up and twirled high, a cape encircles a classic culotte dress, every inch demonstrating the designer's meticulous cut. Photograph by R-J Chapuis, 1971.*

'The classical never meant boring.'

HUBERT DE GIVENCHY

'HUBERT DE GIVENCHY IS AMONG THE FEW COUTURIERS WHOSE CLIENTS SHARE A CERTAIN WAY OF LIFE. FEW ARE LOOKING FOR ONE GALA DRESS. RATHER, HIS CLIENTS NEED SUITS, "LITTLE NOTHING DRESSES".'

MARIE-JOSÉ LEPICARD

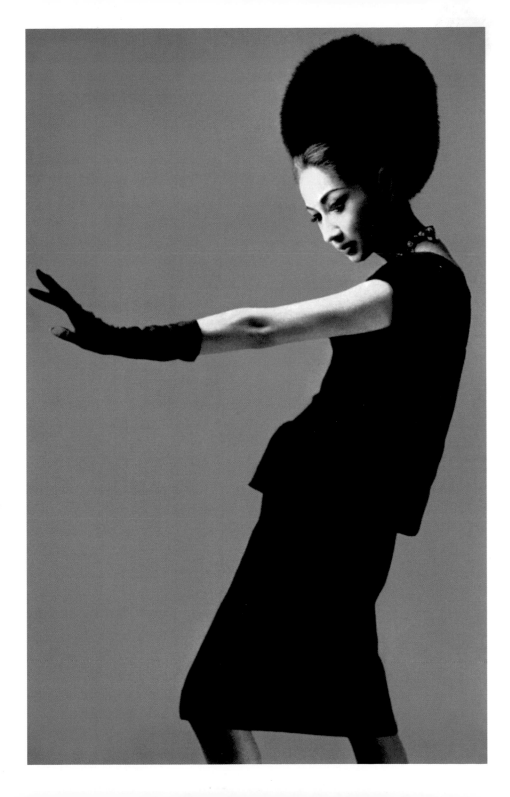

In that observation, he was speaking generally, but his business prospects certainly provided an encouraging backdrop to his existence. The Givenchy label expanded internationally, growing stage by stage into a commercial and industrial force: firstly through store buyers and manufacturers, secondly by ready-to-wear and thirdly by licensing contacts. In the United States and Japan in particular, according to the record, the licensing of local manufacturers to produce for the label proved highly lucrative. In the Seventies, the range of products under his name suggests, logistically at least, that a female devotee would have had little need to stray to another label for her fashion, accessories, appurtenances, cosmetics and perfumery. Givenchy's alluring and extensive costume jewellery collections, literally a jewel in the crown, did not even neglect adornments for the bare foot.

An important addition to the Givenchy label was Parfums Givenchy, formed in 1957. The first time *Vogue* readers heard that they could get their hands on bottled Givenchy was news of the arrival of the scent 'L'Interdit' in 1958. British *Vogue* voted it, 'Exotic, mysterious, heady'. The aroma was said to have been created for Audrey Hepburn who had remarked that she couldn't find one she liked. *Vogue* frequently advised that the scent to wear with the model illustrated was one by Parfums Givenchy. The company, run by Givenchy's brother Jean-Claude, was started on small means and went on to prosper producing scent, eau de toilette, beauty products and cosmetics for women and a range for men. Monsieur de Givenchy, an innovative blend of scent and cologne found special favour and was said to be liked especially by those hesitant about using a full-on perfume. After the sale of Parfums Givenchy to Veuve Cliquot 1981, Givenchy himself fronted the promotion in *Vogue Paris* for a scent, Ysatis in 1985. He was photographed in colour, formally suited and standing beside a giant mock-up of the bottle. Its style is described as 'Vertical, slender elegant. Similar in silhouette to M. de Givenchy himself. '

The words 'Portrait of a creator' head this advertisement for Givenchy Parfums in Vogue Paris, *1985. Here, the couturier poses informally with a bottle of Ysatis in a graphic format that shows the names of six of his perfumery products, written in his own hand.*

previous page *'After Six': American* Vogue's *tip for the hour was this two-piece black dress by Givenchy. 'Back perfectly straight, the front like a concave shield, with a deep unfluttery ruffle on the swing of the curve.' Photograph by Karen Radkai, 1963.*

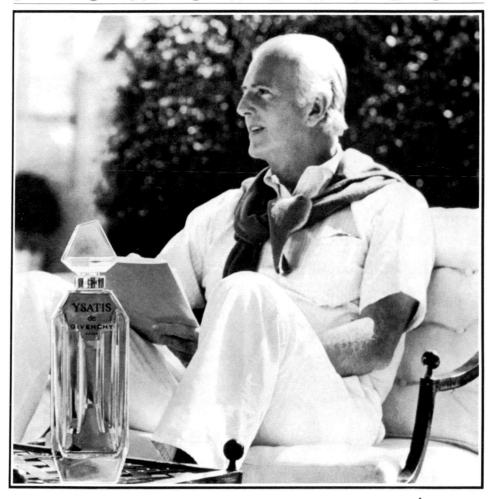

Eau de Givenchy l'Interdit Givenchy III Ysatis Monsieur de Givenchy Givenchy Gentleman

GIVENCHY
PARIS
PARFUMS

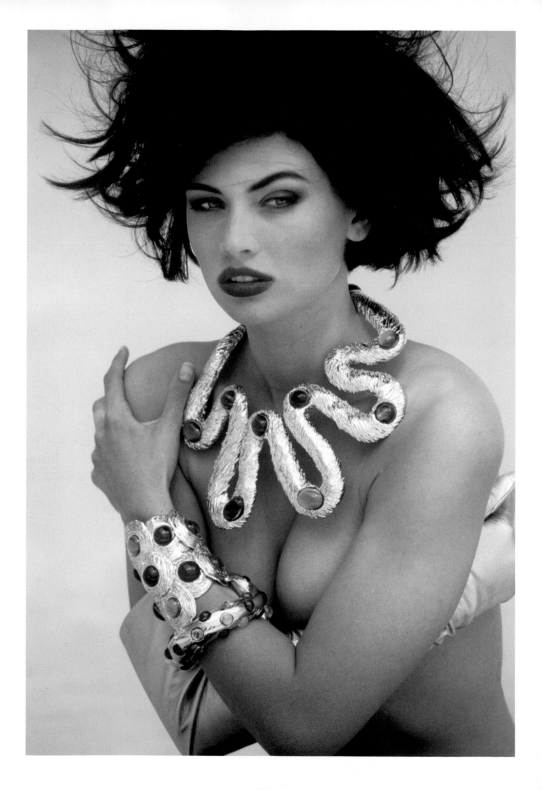

Throughout his years as a couturier, Givenchy drove his house energetically, opening new outlets for his various collections and ranges and being the totally involved master. He took his wares to many different part of the globe and travelled widely himself, participating in all of the following and others: a World Trade Fair, fashion festivals, festivals of fragrance, beauty symposiums, presentations by French, Italian and Swiss fabric houses, promotions with big department stores and numerous charity galas and benefits.

Givenchy's entrepreneurial spirit took on creative fields allied to but apart from couture. He regarded interior decoration as an extension of his design practice, and commissions followed. Among them was the redecoration of five floors at the Hilton Hotel in Brussels in 1977 using a colour palette in his collection – cream, jade, dark brown, mauve and blue. In 1980 he turned his hand to furnishing fabrics before moving on to household linens, wallpaper and tableware. In 1984 he launched his first chintz collection, a favoured fabric of his. Car manufacturers too called on his reputation for elegance. He decorated a new version of the Lincoln Continental Mark V in1977, a large coupe made for Lincoln, the Ford's luxury edition. With an interior done in jade leather, and the designer's signature and house insignia incorporated in the fittings, his take on automobile decoration led to other briefs. In 1984, Nissan the Japanese firm, turned to him for their new limited edition of the Nissan Laurel. American *Vogue* registered Givenchy's interest in automobiles in 1969, photographing him kitted out in a suede outfit cut like a mechanic's overall, posed beside a Citroen Mehari, a dinky snow, sand and field machine.

'Gold – fabric or metal – is the selling of choice for faux gems,' said Vogue. This necklace 'light as a feather' and oversize bangle made use of the newly developed metal-shot materials. All by Givenchy Nouvelle Boutique, photographed by Patrick Demarchelier, 1990.

'A sense of luxe completely
of the present.'

VOGUE

An apparently unsung achievement of the designer's is his ability to combine the roles of being the chief of a business on the scale that the House of Givenchy had become with that of creative leader. This was all the more impressive since no dominant financial wizard is known to have been on board. It's natural to wonder how he cracked it. Catherine Join-Diéterle, writing in 1991 as Curator in Chief, Museum of Fashion and Costume in Paris and co-author of *Givenchy: 40 Years of Creation*, a retrospective, has a thumbnail sketch. 'Besides being an artist,' she commented, 'he is a formidable company director. Imperious in manner, he runs the studio with an iron fist and is as demanding as he is commanding.'

An account by a *Vogue* observer of the artist at work stresses the benefits of the discipline of his early upbringing. Evident in such details, the writer says, as 'his early arrival at the studio, the careful way in which he hangs up his jacket, buttons his white work coat. The toiles brought to be fitted are meticulously ironed before they arrive at the studio. Hubert de Givenchy likes to have all his fabrics around him – the *première* [the *atelier* (studio) head] drapes one on a dressmaker's dummy and when the couturier is satisfied with the way it falls, he makes a sketch and gives it to the *première* to be prepared … Monsieur de Givenchy's desire for perfection is such that he never says "That's good" after the fitting, he says "You see that's better."'

In Paris, 1971, David Bailey photographed Jean Shrimpton modelling the couturier's gaucho jumpsuit in dark brown suede, 'bundled in racoon,' said Vogue of the huge stole and big hat.

overleaf *An American Vogue cover, April, 1954, using drawing and photography. Rene Gruau's illustration of Givenchy's little black dress in jersey is juxtaposed with Erwin Blumenfeld's close-up shot of the face for the season. 'Boater, never bigger,' said British Vogue of this model in natural straw. 'Givenchy makes a flying saucer of a hat, with an optically illusionary scale of a crown. Big enough to contain a vast head seen from the top – inwardly, it keeps to normal proportions.' Photograph by Karen Radkai, 1955.*

'He dresses the woman, but she breathes
life into his creation.'

CATHERINE JOIN-DIÉTERLE

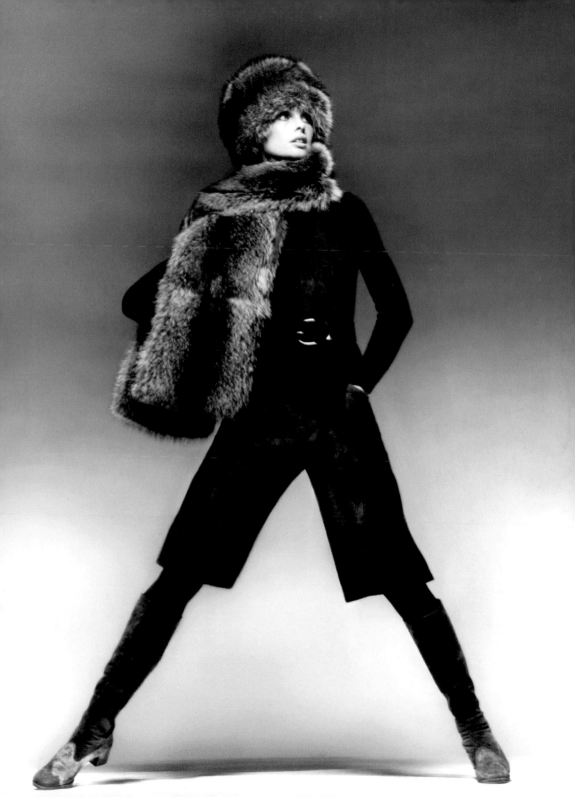

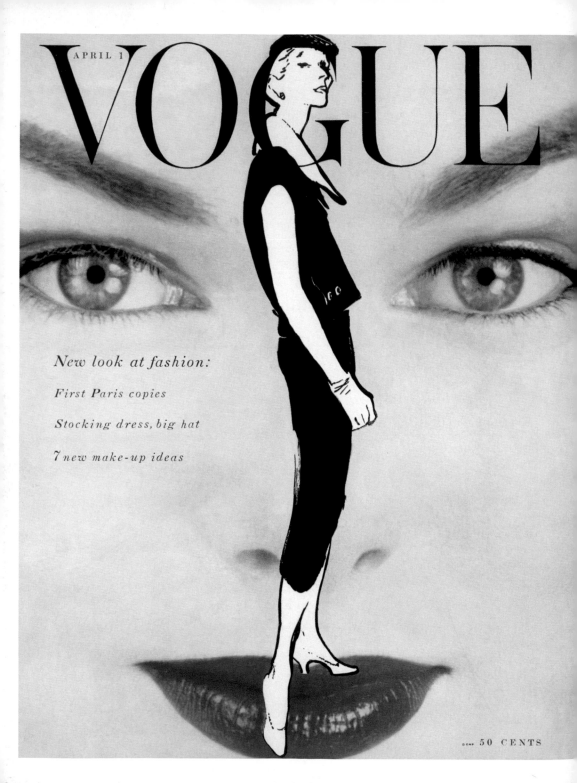

APRIL 1

VOGUE

New look at fashion:

First Paris copies

Stocking dress, big hat

7 new make-up ideas

50 CENTS

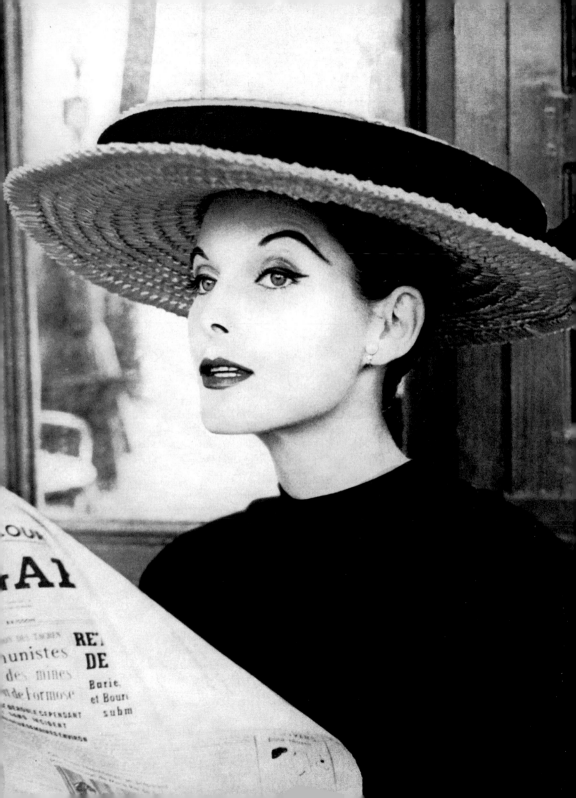

'IT'S VERY REPRESENTATIVE OF WHAT HE DOES BEST.'

AUDREY HEPBURN

THE IMAGE
MAKERS

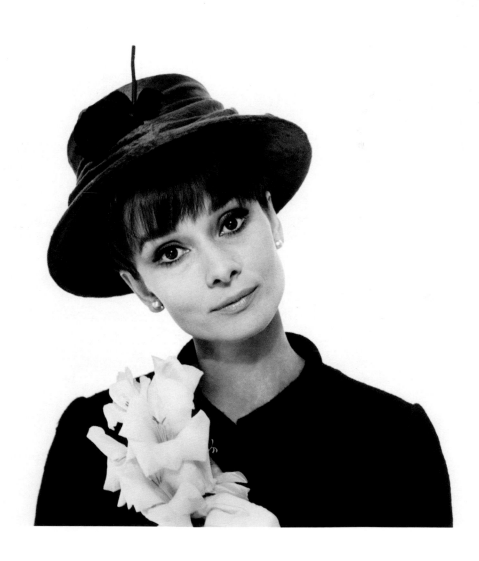

The creative collaboration between Audrey Hepburn and Givenchy provided *Vogue* with a fund of storylines and some enchanting fashion photography. 'We have a wonderful entente together,' Givenchy told British *Vogue*. American *Vogue* remarked: 'What fires his imagination races hers. The message he cuts into cloth she beams into the world with the special wit and stylishness of a great star.' The 'entente' caught the eye of the magazine most prominently in the Sixties, calling on the actress's talents as a fashion model and commentator on the collections. Although Hepburn's appearances in the three editions of *Vogue* played on the dream match between her style and his fashion, it's worth mentioning that the entente also taught her a great deal. 'Givenchy helped to create her image quite as much as any of her directors,' says the film critic Alexander Walker in his biography of Audrey Hepburn. 'It was from him that she acquired the cosmopolitan touch that distinguished her from the other young stars of the day. Such an education was much in evidence in her role in *Vogue* as Givenchy's ideal model. Maybe we can see Givenchy as having something in common with Professor Henry Higgins, the character in *My Fair Lady*, based on George Bernard Shaw's version of the myth of Pygmalion. They both are seen to effect a transformation of Hepburn's image: Higgins fictionally upon the character of Eliza, the Cockney flower girl played by the star, the designer in reality in his influence on Audrey, his Muse.

In 1963 American *Vogue* devoted a near-unprecedented ten-page portfolio to the star styled in Givenchy, photographed by Bert Stern. She is quoted on her reasons for selecting each design. Of a hyacinth-pink tweed suit with a deeper pink linen over-blouse, she remarks, 'I wear lots of pink, and I love this colour. I particularly chose this to show the blouse.'

Audrey Hepburn plays on her role as Eliza Doolittle, modelling Givenchy's reworking of Cecil Beaton's original version. The re-creation: emerald green melusine embellished with a faux rose. Photograph by Cecil Beaton, 1964.

overleaf Audrey Hepburn in evening Givenchy. On the left, gauze-dotted shantung curved to the body, with a décolletage 'like a night blooming flower,' said American Vogue. *On the right, a déshabillé of cloque silk printed in shades of china blue. 'I love that string-bean-with-a-bow look,' commented Hepburn. Both photographs by Bert Stern, 1963..*

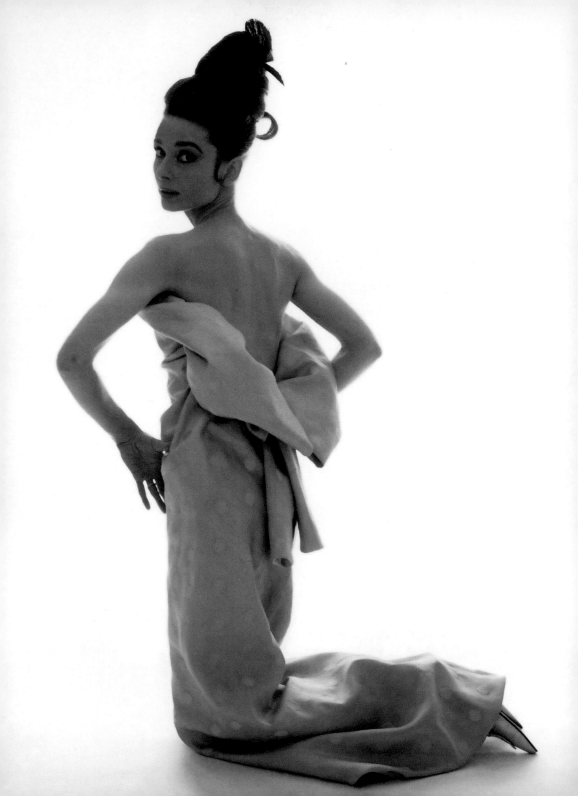

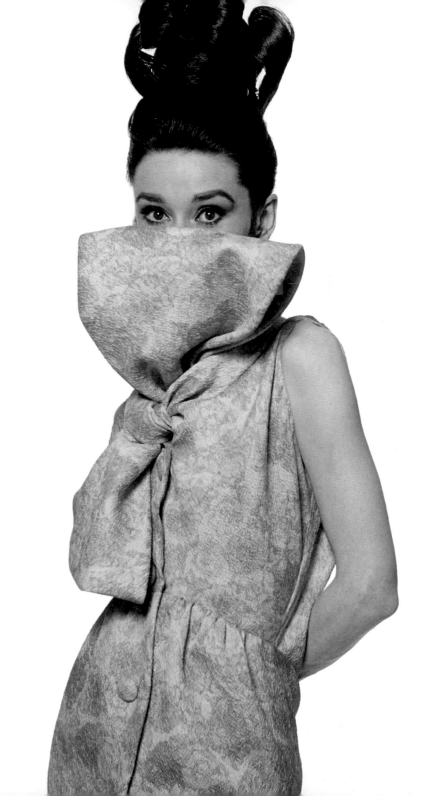

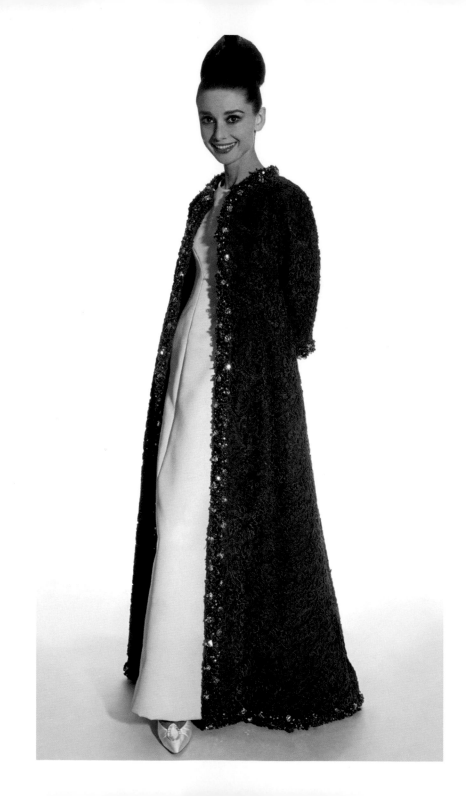

'THIS IS ONE OF THE MOST ENTICING OF GIVENCHY'S THEMES, A DREAM OF CUTTING AND SHAPING.'

Another comment on an evening dress in gauzy dotted shantung: 'Very teahouse' said Miss Hepburn, 'It's like a tiger lily – a wonderful colour at night. Radiant and life giving. And it's wonderful when a dress can make you take on another personality.' On another design: 'This' explained Audrey Hepburn,' is the purity of Givenchy and the kind of dress I wear in the daytime. It is very representative of what he does best.' She is talking about a jersey outfit that incorporated one of the designer's house signatures, a sleeveless over-blouse. Slipped over a small top with a skirt, an over-blouse turns three pieces into an unquestioned dress.

Givenchy fashion linked to *My Fair Lady* ran and ran in *Vogue*. The star and the couturier collaborated on a fashion feature in American *Vogue* with Cecil Beaton, the designer of the costumes for the original *My Fair Lady* on stage and who designed the costumes and sets for the movie version. In 1964, Beaton photographed Audrey in four of Givenchy's designs declared to be 'The New My Fair Lady Hats'. One of these is the couturier's redesign of the intentionally drab item devised by Beaton for the character of Eliza Doolittle, the poor flower seller. It became a brimmed toque of emerald-green brushed melusine embellished with an open black rose. For this shot, Audrey is in the character of Eliza. Beaton once observed in *Vogue*, 'Nobody ever looked like her before World War II … now thousands of imitations have appeared. The woods are full of emaciated young ladies with rat-nibbled hair and moon-pale faces.' Subsequently, he conceded that her whole quality overcame any deviation from the norm of beauty.

In November 1964 the actress was on the cover of American *Vogue*, photographed by Irving Penn, smiling in the designer's 'plump little melon hat of emerald green velvet'. The issue announced 'Audrey Hepburn wearing – again for *Vogue* – her favourites from the Givenchy collection'. One of the main shots shows her in a floor-length opera coat of violet lace, beaded and embroidered and slightly trained.

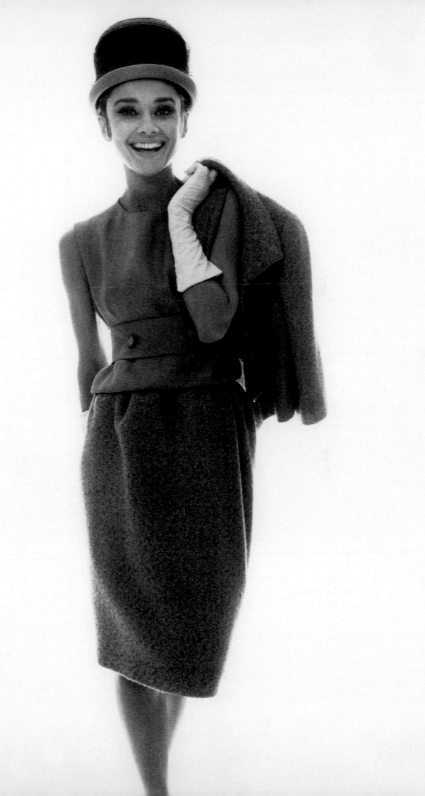

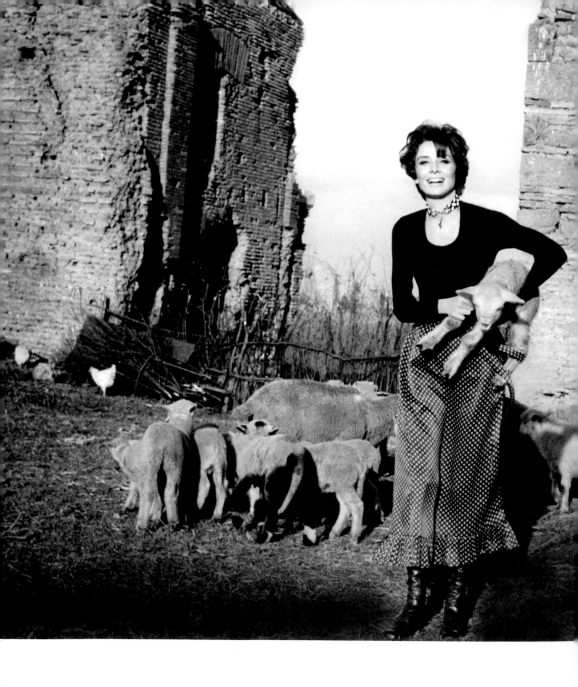

'AUDREY HEPBURN
HAS LOOKED ALL
HER LIFE AS IF EVERY
MINUTE AND EVERY
NEW FASHION WAS
BORN FOR HER.'
VOGUE

*'She loves the long light-
weight skirts ...' announced
Vogue Paris of the latest
arrivals at Givenchy
Nouvelle Boutique. Audrey
in white spotted navy silk by
Hurel. Narrowly sashed at
the waist, a softly gathered
skirt falls into a pleated
flounce. Photograph by
Henry Clarke, 1971.*

'At Givenchy, evening dresses spell allure, the most revealing his halter-top dress in shades of fuchsia chiffon print, slashed to the waist in front, made with a matching transparent cape,' said American Vogue in its Paris collections review of 1975. Photograph by Sarah Moon.

It is worn with a long white satin robe with a lifted waist, reminiscent of Gothic tapestry figures. The copy hints that the coat and dress might be the star's choice for the forthcoming opening of *My Fair Lady* in New York.

Audrey Hepburn proved a real trouper and acted out the roles suggested by the Givenchy's designs in which she was styled. All three editions in 1971 published a story on the star modelling Givenchy Nouvelle Boutique outfits designed for the better-dressed countrywoman, photographed by Henry Clarke in a pastoral setting outside Rome. The fashion focus is on the new long skirts. Posing curled up on a resting place in a haystack, the actress is styled in dresses at ankle length, one in cyclamen chiffon, the other in a garden flower print. Elsewhere on the shoot, shown hugging a lamb, she is all smiles in a fitted long-sleeved top of navy blue and an easy-to-wear skirt in a white spot on a navy ground, tied at the waist with an ankle-brushing flounce at the hem.

Such fashion stories caught the diversity of Givenchy; his collections both couture and ready-to-wear lent themselves brilliantly to interpretations by photographers and fashion editors. In September 1970, for instance, American *Vogue* published a story on the model and actress, Ingrid Boulting, a romantic beauty. She is turned into a 'Proustian housekeeper', styled in a 'strict, fitted, flounced, ravishing dress of violet faille with velvet dots, velvety scallops.' In the same feature, Lauren Hutton, the famous American cover girl known for her healthy glowing looks is shown in a sweater and skirt outfit by Givenchy that befits the model's reputation.

Taking account of his seasonal couture collections, the ready-to-wear lines and the Audrey connection, Givenchy was ubiquitous in *Vogue*. But what jumps off the page is less the catholicity of references than the quality of the images done by the magazine's stable of photographers and fashion illustrators. Scarcely a practitioner of consequence in either field has not at some point had a turn at realising a Givenchy for *Vogue*. A synergy seems to have existed between those who were interpreting his designs in another medium and the mind of

the creator of the original. The architectural outlines of the clothes, their subtle relationship with the body, the vibrant colour, unusual fabric combinations and significant detail proved to be subjects that photographers could visualise in their own light. They would sometimes regard the shoots as an opportunity to impart a wider message about fashion and society, the pictures serving as micro documents of the zeitgeist.

The freshness of what was going on in fashion communicated itself to the magazine in a manner that has lasted. Cecil Beaton turned to portraiture for his fashion shots of Audrey Hepburn. Horst P. Horst's compositions of a model in a setting have an emblematic quality. Richard Avedon in American *Vogue* in 1970 seized on the quality for which Givenchy is renowned – clothes that move naturally with the body. He shoots the models in active stances, something like a still from a movie. Likewise, fashion artists: René Bouché's drawing in American *Vogue* depicts day suits on figures that are clearly headed somewhere, and Eric (Carl Erikson) finds romanticism in his evening clothes. Helmut Newton and Sarah Moon found material that could be dramatised in ways that express the ambivalent nature of human sexuality. Irving Penn, Norman Parkinson, Bert Stern, Henry Clarke, Kublin, William Klein, Clifford Coffin, Arthur Elgort and Barry Lategan are among those who produced images that echoed American *Vogue*'s view, aired in the mid-Fifties, that 'Givenchy sees women deliciously.' David Bailey in Paris with Jean Shrimpton endowed the English beauty with an air of Gallic sophistication. Guy Bourdin created psycho-drama using Givenchy as costume for characters in a scenario and, as well, creating memorable still lifes. Jacques-Henri Lartigue expressed his sense of comedy. Deborah Turbeville's model was cast to hint at a questioning, interior life. Bruce Weber, Eric Boman, Arthur Elgort, Patrick Demarchelier, Francesco Scavullo, Frank Horvat and others of distinction added their stamp to the portfolio.

These 'day-to-day' suits in American Vogue *are portrayed as on the move somewhere, anticipating the lifestyle of likely wearers. Cropped jackets, fringed fabric and three-quarter-length sleeves predominate. Illustration by René Bouché, 1957.*

overleaf A city suit admired in Vogue Paris *for its fluid silhouette, accentuated shoulders and contrasting materials. The tailored jacket in vert-bronze (green-bronze) wool is detailed in black velour – the fabric of the skirt. Accessories: a silk print blouse, plumed hat and fur muff; all by Givenchy. Photograph by Elliott Erwitt, 1978.*

'HE DOES NOT OUTMODE, HE REPLACES, HE RENEWS.'

MARIE-JOSÉ LEPICARD

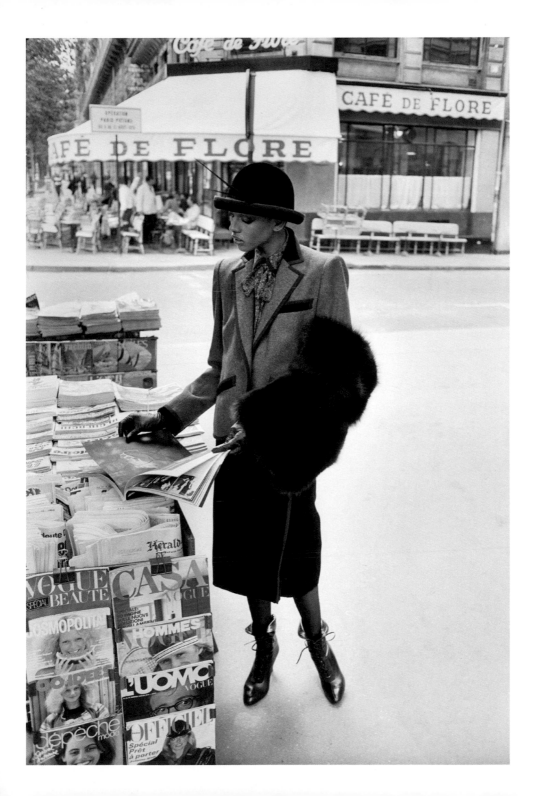

Interestingly, in the late Seventies, Magnum's Eliott Erwitt adopted a documentary street style as a means of expressing Givenchy's modernity. In September 1994, the year before Givenchy's bowing out, Mario Testino photographed a long jacketed suit, attenuating the string-bean length and sleekness of the style that has been the designer's from the start.

The increasing use of colour film in fashion photography in the European editions turned a light on Givenchy's palette; this was an advantage for a designer renowned for rare fabrics and original colour combinations. In the Seventies when the couturier's 'masterly fabric treatment' was singled out for comment, a photograph by David Bailey illustrates the benefits. An image of a long sheath of copper organza, vertically striped in iridescent sequins, created in a design of a cardigan-style jacket slipped over a sleeveless dress, glows against a back ground of coppery and verdigris shades. Black and white would have told only half the story.

British Vogue announced 'In Paris ... Givenchy's copper organza with sequin stripes.' The design of the buttoned cardigan and sleeveless evening dress play on the geometry of the striping. Organza by Abraham, sequin embroidery by Lesage – two of Givenchy's leading specialist suppliers. Photograph by David Bailey, 1972.

'Today as I was working I could feel
Balenciaga's hand on my shoulder.
He was saying: Subtract. Make it simple.
Make it pure.'

HUBERT DE GIVENCHY

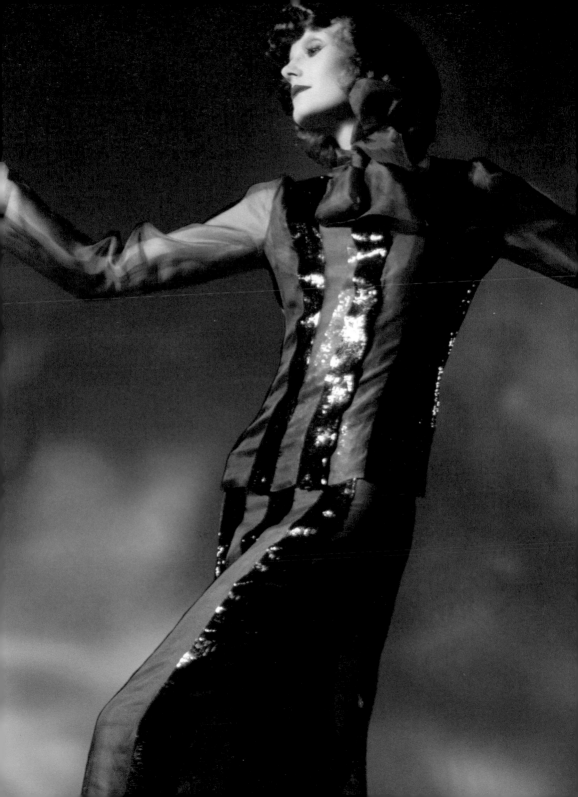

'KEEPING FAITHFULLY TO HIS OWN PARTICULAR STYLE.'

CÉLIA BERTIN

GIVENCHY STYLE

Perhaps the only way to appreciate the full beauty of a Givenchy original would have been to order a design and wear it. The art of couture is hard to translate into words or photography as it is a question of a trillion little tricks of the trade put at the disposal of the wearer. There is so much canny knowledge in its tailoring, cut and design, to say nothing of the quality of imagination. Givenchy called on many cultural and artistic sources for ideas for his collections. He had a predilection for looking eastward for instance. The proportions of Arabic robes, Chinese-influenced silhouettes, turbans, harem skirts, Kashmiri colours, the shades and shapes of the garments of India, kimono sleeves, the development of 'satung' a mixture of satin and shantung, are a few random examples. But then, too, he looked to the history of the decorative arts of his own country.

Overall his gentle shifts of style are reflected in his stance on the dominant silhouette in couture; a progressive form that valued the wearer's freedom of movement. 'Women don't only wear a dress, they live in it,' he has remarked. His silhouettes were by definition free of a sense of constriction. Many of his outfits in *Vogue* are influenced by a cone shape, the A line being a direct descendant as was baby-doll – all forms that kept a distance from the waist. Equally, his collections included models in which the waist is well defined but in a manner that escapes a tight fit. Givenchy's school of couture ran counter to that of his contemporary Christian Dior. The latter's elegant but nostalgic New Look followed an hour-glass outline, nipped in at the waist and with accentuated hips. As has been said often, it was a construct calling for control and restraint. The difference between the philosophies hung on whether a garment should adapt to the body or the body be made to fit the garment. Givenchy's approach eschewed artificially stiffened fabric and restrictive padding and corsetry.

'Black used in strong, beautiful bravura strokes with dazzling, very feminine additions of white,' observed American Vogue. *Henry Clarke photographed the baby-doll fashion in 1956, in front of a painting by the French artist Bernard Buffet.*

overleaf *A tabard to make yourself (left). The original, designed by the couturier, was featured in British* Vogue, *with dressmaking advice. Photograph by Barry Lategan, 1976. 'Ready for a two piece bathing suit that's nothing more than a couple of white petunia petals?' asked American* Vogue *in 1969. Givenchy's design (right), photographed by Bert Stern, is in embossed cloque nylon by Bucol.*

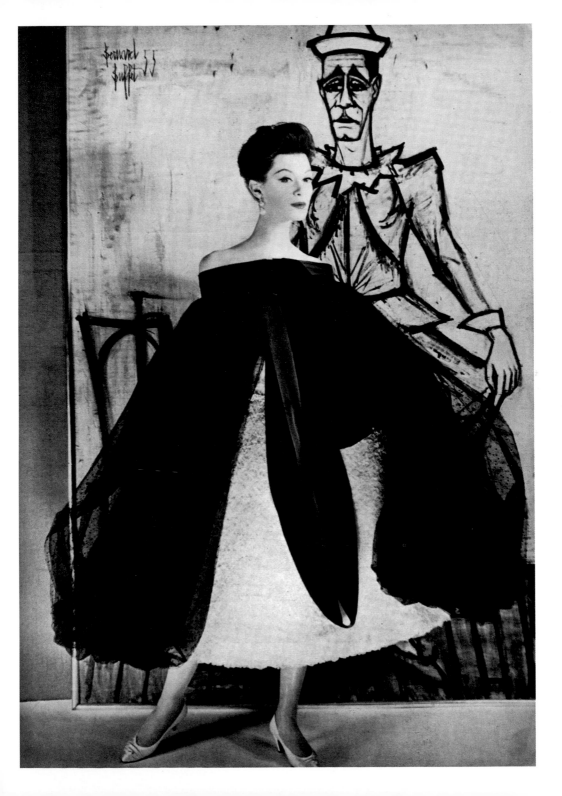

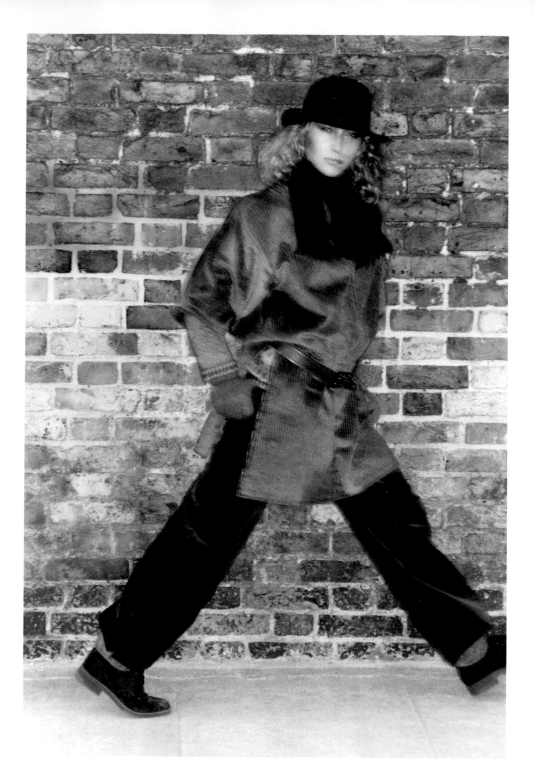

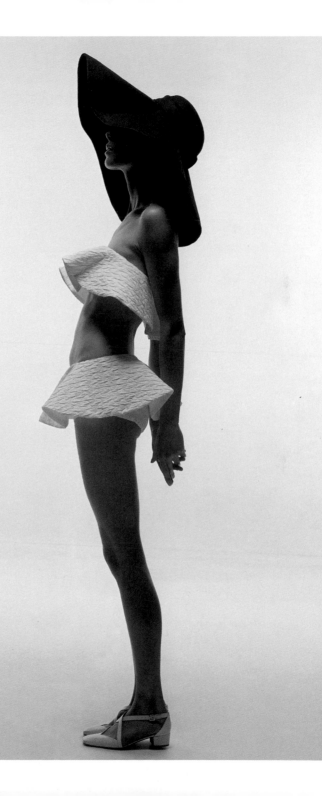

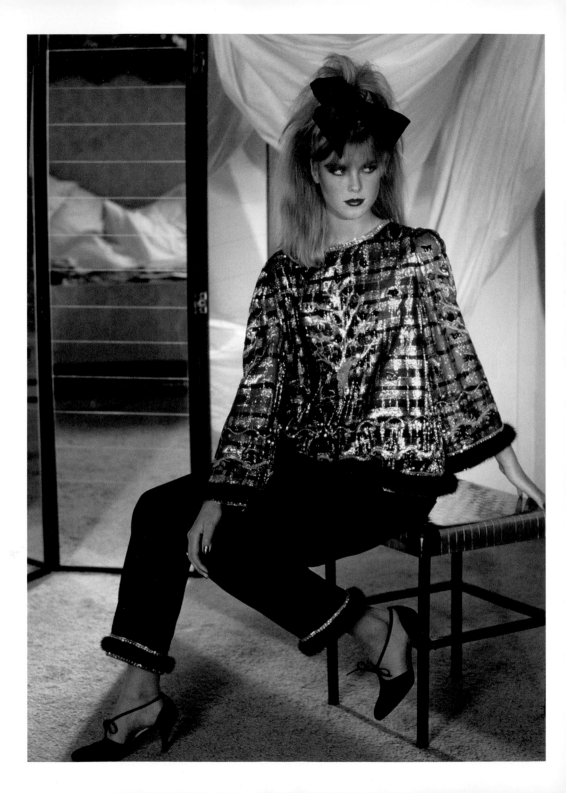

Costume historians credit him with certain original concepts. A wool day dress in four 'tiers' with a small collar in which the top three tiers of the design are bloused and the fourth straight, serves as evidence of his belief in 'the harmony of proportions'. His collection of Separates for couture-minded clients is acknowledged – among other virtues – as circumventing one of the problems of a dress, that of the length of the waistline. Myriad differences that exist in the female waistline were neatly accommodated in his sophisticated pick-and-mix selection. Sleeve length in the balance of a design is a theme he made his own, variants of the three-quarter measure in particular. He also perfected a collar – for example, on a suit – that keeps its tension shape and gentle curve. He was responsible for the development of asymmetry in day and evening clothes. A novel synthetic material, cigalene, was developed for Givenchy by the fabric house Bucal and was characterised by tiers of flounces on a solid ground. He made it up into knickerbockers among other designs. The tunic was a subject for reinvention: as a component in a tunic coat-dress, as a crew-necked sleeveless garment and also in a form that was shorter in the middle of the front and wider in the skirt. Tunics were designed to be worn over short or long skirts or over trousers of many different lengths. One model comes banded at the hem in white mink. Along with the tunic comes the reworking of the tabard, medieval in origin, which proved a twentieth-century winner. *Vogue* offered advice on making it.

'Givenchy's Glorious Smock of Gold' declared British Vogue. Photographed by Eric Boman in 1980, the top, banded in jet-embroidered mink, is accompanied by velvet trousers.

Certain creative practices in his collections occur over and over again. A classicist, he modifies severity with detail. Passementerie buttons using embroidery and thread represent, in their number and placing, almost a meditative art form in his discipline. A small element, for instance a scrap of a hat, often expresses the whole spirit of a design. Stoles, scarfs, fichus soften the silhouette. Collars come in dramatic differences of scale and shape. They can appear very small – sometimes as just a tongue of fabric rising above the neckline.

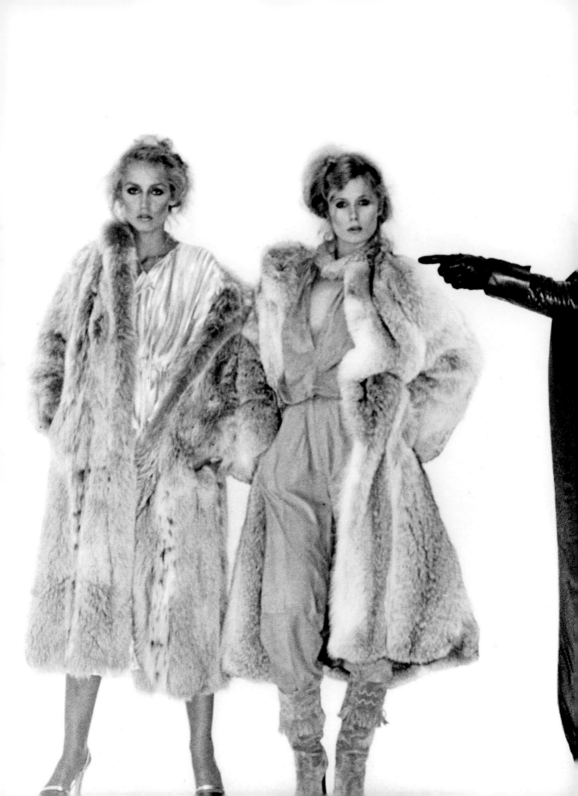

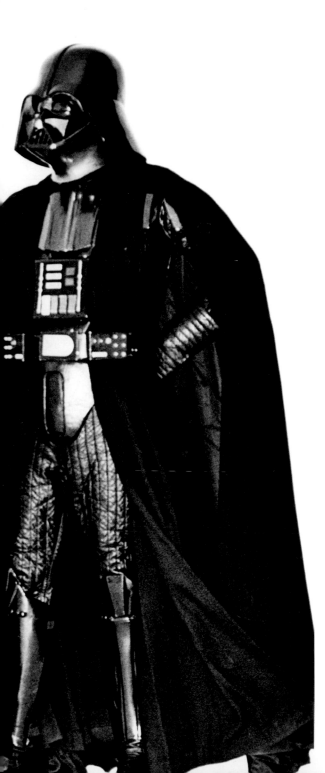

'SPIRITED, SPECTACULAR, LUXE.'

VOGUE

Darth Vader, Star Wars villain, lends his image to a spread on 'The "Force" of Fur' in American Vogue, 1977, photographed by Ishimuro. Vogue described the central outfit, a big, soft coat of 'silky blonde natural coyote – slipped over pale suede,' as 'sensational Givenchy.' The fox fur on the left is by Maximilian.

overleaf *'Givenchy wild about his animal prints', recorded American Vogue in 1969. On the right, a top coat in 'tiger wool'; on the left, a trouser suit in leopard-printed stretch gabardine. Photograph by Irving Penn.*

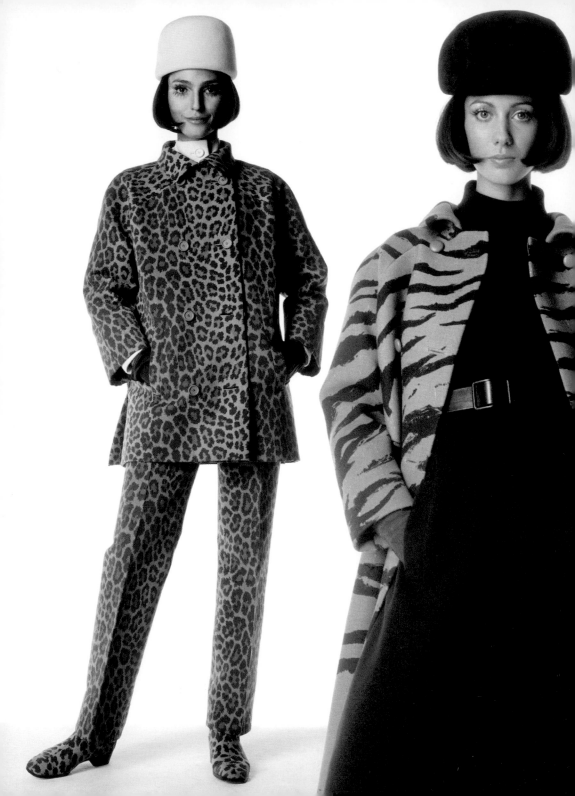

'GIVENCHY'S ENTIRE
WORK REFLECTS HIS
TASTE FOR ANIMAL
SUBJECTS AND FURS.
AS EARLY AS 1953
HE CREATED ...
IMITATION GOLDEN
OTTER, PEARL MINK,
PLATINUM MINK,
BROWN BEAVER,
SILVER FOX.'

CATHERINE JOIN-DIÉTERLE

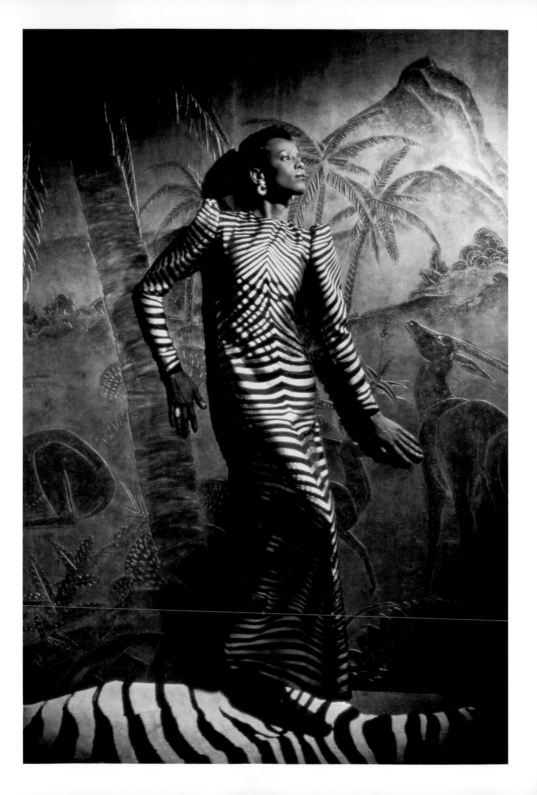

At other times collars appear as stand-up and stand-away; sometimes they are funnel shaped and, on top coats and jackets, sometimes huge and enveloping with sable or fox on the big ones. Bows, in common with collars, can be entertainingly small or extraordinarily big. Pockets, belts and buckles may become decorative elements, sometimes in the cause forgoing their practical function.

A zebra print composed as a long evening dress, posed against a mural depicting an imaginary landscape of palm trees and wild game. Photographed by George Hurrell in 1980 at the decorator Alberto Pinto's apartment where Givenchy's Collection was shown.

overleaf 'The print restored' exclaimed British Vogue featuring the designer's leafy black-and-white silk dress (left), the fullness gathered over the hip, ballooning sleeves held by wide cuffs. Photograph by Henry Clarke, 1952. Three decades on, Givenchy works a gentle floral print as two pieces (right), a wrap blouse together with, as American Vogue put it, 'a flirty wrap skirt and sash to bow charmingly at the waist.' Photograph by Arthur Elgort, 1982.

Asymmetry and a predilection for fabric cut on the bias and, too, a combination of bias cuts with straight, finds expression in garments of all kinds. Gazar, a silk or wool weave that holds a cut shape well, is a frequent choice for evening clothes and their capes. The tailor in the couturier is always on call.

'No-other designer can match Hubert de Givenchy's lifelong flair for associating different materials,' comments Catherine Join-Diéterle. The designer is a dedicated mixer of materials, either as an integral part of a garment or as insets. Double-faced coats of materials that are of equal status are a constant feature: one made in a plain black broadcloth lined in waffled blue crêpe is characteristic. Furs, leathers, suede and snakeskin are worked into fabric. He puts flannel with velvet, moiré with wool, fur with suede, tan leather with a ribbed black jersey knit. A cocktail dress combined silk, velour and muslin. Tapestry is edged with fur. Persian lamb is set on leather. A cobra-skin coat edged in dyed marmot is recorded.

A love of pattern flows through his fabrics. He harvested ideas from the Renaissance, from China, Africa, Egypt and from the arts of his own country. A toile de Jouy design took form as a dinner dress. A print of his is based on Christian Bérard's sketches of cherubs' faces and trompe l'oeil ribbon bows. Modern artists inspired him. In fact, he was among the first couturiers to find inspiration in works by Miro, Rothko and Braque; Henri Matisse's painting 'Peasant Blouse' and Raoul Dufy's realisations of palm trees provided motifs. Animal prints abound in his fabrics: leopard, zebra and giraffe.

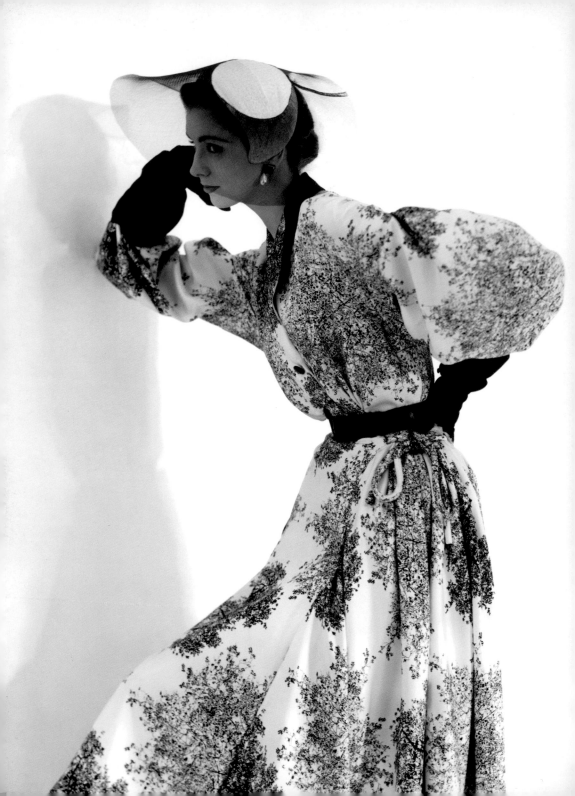

'HE SEES FABRICS WITH THE EYES OF A PAINTER AND SCULPTOR, ADMIRING THE MOTIFS, SHADES, TEXTURE, QUALITY AND FALL.'

CATHERINE JOIN-DIÉTERLE

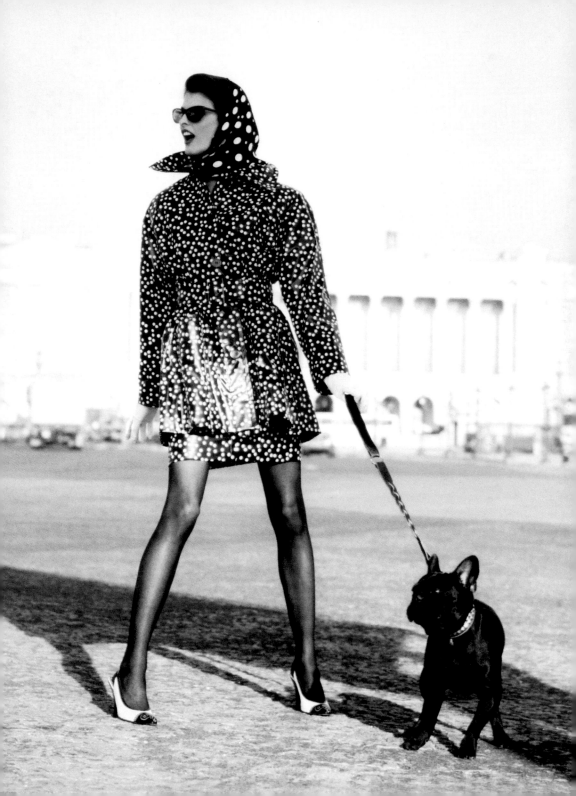

Representations of vegetables and fruit are also sources for emblems. Join-Diéterle notes that although pineapples had been used in fabric design since the eighteenth century, 'It was Hubert de Givenchy who added blackberries, wild strawberries, bigaroons (a large cherry, red on one side, white on the other), gold and green grapes, oranges and lemons – the curled zest reminiscent of early still lifes.' One of his most memorable in this genre is a print for a summer dress with a repeat pattern of slices of a plump tomato. Along with Givenchy's eye for the vegetable and fruit kingdoms comes an appreciation of flowers as motifs, his preference being for the plants he grows in the country: poppies, cornflowers, daisies, lilacs, anemones, tulips, with lily-of-the-valley being the favourite. In the 1980s he used three-dimensional forms of leaves, flowers and petals scattered on a dress design that, according to an account, 'floated gently with every step'. Embroideries are synonymous with his name and were created with specialist fabric houses; one shown in 1990 combined cabochons, gold, cut-out plastic and feathers.

Panels, capes, folds, pleats are worked in a way in which they are integral to the construction and silhouette of a model. Cape-coats make an appearance, one design cut like a coat in front, like a cape at the back. Pleats are the making of the ease and freedom of many models and are part of the construction of décolletés, bodices, sleeves and flounces at the hem. An era of pleats is followed by draping as way of defining a look.

All in all it is unwise to try to typecast him. He liked to try out the untried, producing such conceits as a romper in lattice-work chenille sprinkled with velvet flowers. He paired trousers with a bare midriff top called 'moon bathing' tops and designed long trousers in what was greeted as 'the new transparency'. His 1971 collection was described as 'everything luxe, sportive and chic'.

Tomato print dress, sleeveless and buttoned beneath a bared back, reflects Givenchy's raid on the fruit kingdom for motifs. The little close fitting cap, too, is tomato red. Illustrated by Eric, 1953.

__previous page__ Black-and-white spotted suit in ciré, photograph by Peter Lindberg for British Vogue, 1987. A short raincoat belted over a pencil skirt, its hemline finely gauged to give the brief skirt its due. The spotted story continues in a tied headscarf.

An ability to unify his two sides as traditionalist and innovator was noticed early on in his career by Célia Bertin, a prizewinning French novelist. In her memoir, *Paris à la Mode*, she says, 'His fanciful imagination does not prevent him from keeping faithfully to his own particular style.'

If one wishes to see Givenchy at his most theatrically luxurious and decorative, the decades to turn to are the 1980s and subsequent collections. Capucine sets the tone in 1981, modelling a showpiece evening robe in black-and-gold printed satin with an inset of black-velvet-edged gold. Critics have said that the early years showed the couturier at his most purely creative and inventive and that during the latter part of his reign, when conspicuous flamboyance was called for, he was the couturier to go to for status dress. But whatever else he created, his classics remained a characteristic of his collections until the final stitch.

To some extent, the three *Vogue* editions found their own Givenchy, accenting aspects that corresponded to the readership and publishing interests. The Brits admired his couture cleverness and the appropriateness of his lines. The French fully supported one of their own, editorially in a special fondness for his more formal evening clothes and his beach wear, as well as in the number of fabric house advertisements which carried his name. The Americans had a huge appetite for his twentieth-century modernity. It goes without saying that *Vogue*, irrespective of national identity, fell for Audrey as Givenchy's Muse.

'Givenchy, stands for beautiful, understated clothes that women love wearing forever.'

VOGUE

C oincident with what could be called the Audrey years in the editorial was a pronounced swing of the fashion pendulum related to the waistline and hemline. It's interesting to see how *Vogue* reported Givenchy's gradualist approach to the altering silhouette. His moves among those of other leaders were followed like star signs. Some examples here give the flavour of *Vogue*'s coverage.

In April 1954 the news was of Givenchy's suits, one with 'the jacket bloused, but the waist still marked. The only fitting is done by a tie belt' and of 'his jumper suit of red jersey moulded only by the fabric, not the cut.' The natural waistline is in retreat; while in September 1955 'Givenchy's evening black satin coat reflects the Orient at its most dramatic. It has a huge cape collar ending in a bow in front.' The collar screens the gently shaped waistline, hemline is at the lower calf. In April 1957 *Vogue* writes, 'Givenchy indulges his famous sense of decorative fun by buttons, bows and furbelows on the shortened skirt of his tube shaped dresses'. The identified shorter skirt has a hemline that hovers below the knee. By September 1958 *Vogue* commends 'The High Waistline', liking the 'subtle feminisation of the shapeless chemise,' and noting that the length of skirt for day clothes remained at knee level at Balenciaga and Givenchy.

overleaf A tweed shift diagonally seamed on the bodice (left); a short measure of a rouleau belt, slightly raised, indicates the waistline. Photographed in 1963 by Karen Radkai for British Vogue. *Candy pink, candy striped, the deep flounce curving round the shift is all movement (right). Here, waistlines are down and hemlines are up. Photographed by David Bailey for British* Vogue *in 1967.*

Moving ahead to 1966, hemlines lifted progressively, and Givenchy's shortest coat ended two inches above the knee in the April of that year. 'Everything moves with ease, often belted but not fitted' is the news. A year on at *Vogue Paris* came the announcement, 'Givenchy … adopts "le short", short dresses, short suits and trousers like the tennis togs worn by Englishmen.' By September 1969 the waist was back at base, and as to hemlines, the British *Vogue* headline ran: 'Everything goes (mini, midi, maxi) so long as it works for you'. An Ungaro coat illustrates a thigh-high mini, Yves Saint Laurent's jersey suit is knee length, while Givenchy is represented by a single-breasted maxi coat, belted. American *Vogue* in March 1970 declared that Paris said that this was the year to do your own thing with your hemline, a statement illustrated with a Givenchy midi dress.

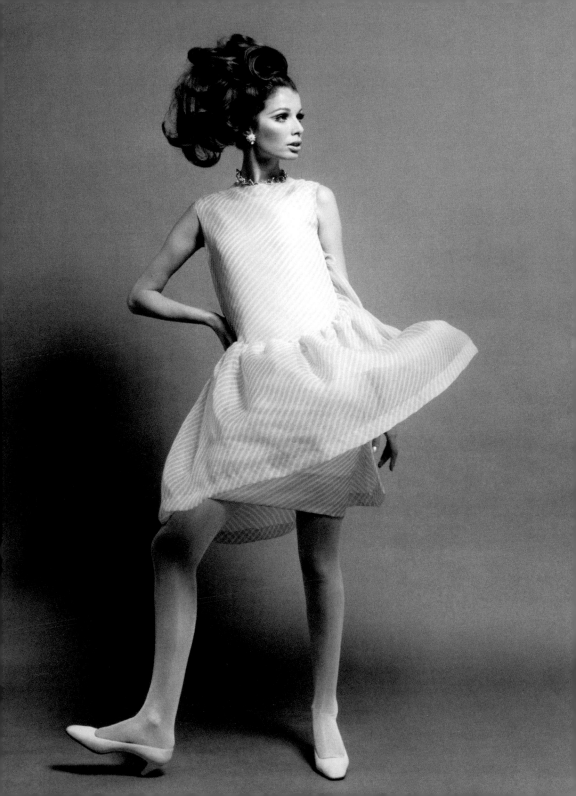

Whatever the seasonal trend of a Givenchy model, certain traits belong to the artist's DNA. A sense of the harmony between garment and material is one such example. Attributes to be expected of couture it may be said, but in the designer's case, the synthesis probably owes its force to his unusual priorities in the making process. Whereas customary practice is for a drawing of a new model to exist and for the fabric then to be selected, with Givenchy the procedure is reversed. As he explained, 'The fabric is the thing that inspires you first. Then comes the creation (of the design) and knowing how to give the fabric its best possible value.' He has said: 'The smell of silk is unique.'

Absorption with the potential of textiles is fundamental to his practice. He said in a magazine interview, 'If I have an idea and the fabric reacts differently, it should not be used.' The designer made a point of visiting the specialist fabric houses in France, Italy and Switzerland, and often worked with them on texture and design, usually it is said, asking for simplifications. *Vogue Paris* published a painting by the Colombian figurative artist Fernando Botero in which one of his symbolic rotund female figures is portrayed in a Rubens-esque bare-shouldered Infanta dress, the fabric realised echoing one in the Givenchy's current collection.

The vibrant colour, graphic motifs and mixture of fitted and flowing combine to give Givenchy's shocking pink and yellow ensemble – a cut-velvet sleeveless coat over a crêpe de chine jumpsuit – a dramatic and glamorous air. Photograph by Irving Penn, 1967.

His take on sartorial sensuousness is another touchstone. It's in the nature of Givenchy's style that the erotic is contained within a measure of discretion. Hebe Dorsay, fashion editor of the *International Herald Tribune*, had another way of putting it, 'Givenchy makes anyone from anywhere look like a lady.' Although he is known for creating some of the most decadent of décolletés and the sassiest of beach wear, the suggestive or louche is absent in the concept. His ball dresses and gala occasion clothes achieve a balance of glamour and propriety that is so hard to get right – to judge from efforts in the current public arena. Yet there is nothing Minnie Mouse about his designs when a spectacular effect is called for. Consider an example from the 1967 couture collection: a resplendent jumpsuit in yellow silk styled with a long sleeveless coat in shocking-pink cut velvet, printed in a pattern of yellow Chinese-style trees – the coat open on one side from hip to hem.

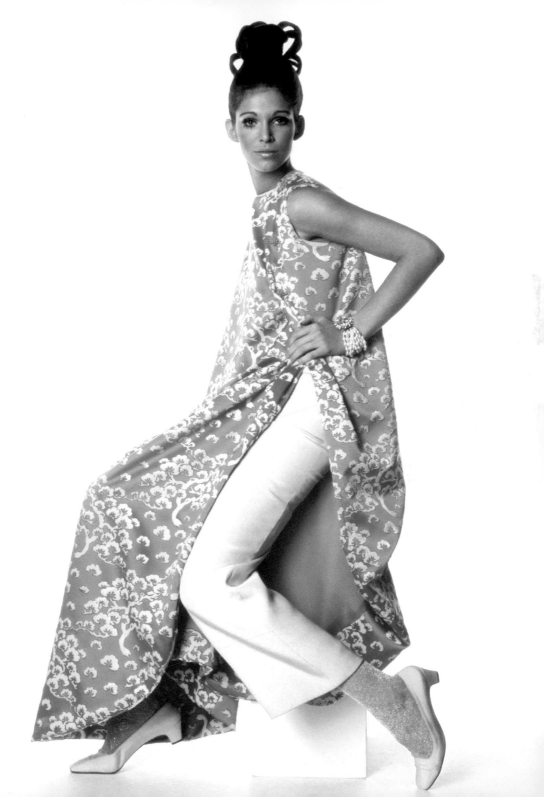

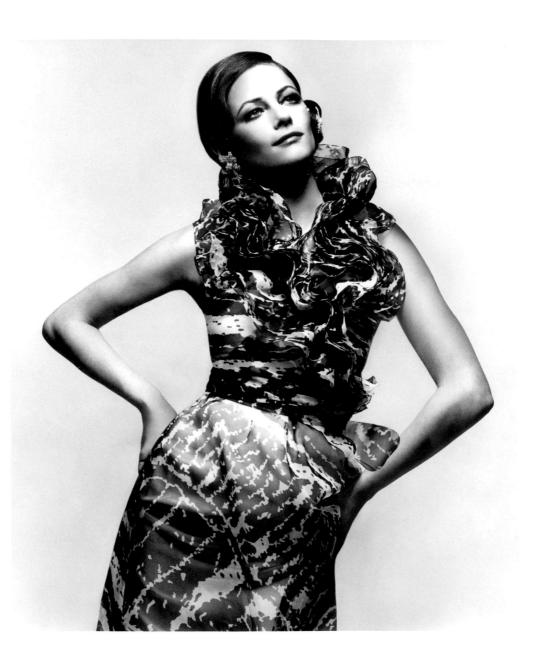

The same nuanced sensuality applies to his little black dinner and cocktail dresses. He has a way of treating one bare shoulder or a bare back or a neckline as a canvas for invention and surprise. The bareness maybe contained within cut-outs shaped by the lie of the fabric, or modified with narrow straps or bands of fabric or halter-like designs, be the recipient of a tied bow or shaped as a deep V open to

the waist. Then again, a crescent-shaped form may adorn a bare back as in Audrey Hepburn's most famous black dress in *Breakfast at Tiffany's*. *Vogue Paris* published a posse of embroidered black cocktail dresses on mannequins, with hemlines just above the knee, which prompted the couturier to define feminine elegance. He says, 'I see the woman of the winter of 1978–1979 as ultra-sophisticated, attentive to every detail and beautifully refined … black stockings, boas, slit skirts can be a caricature of a certain type of woman but a distinguished look lies I believe in the balance of proportions, in the quality of material and in the sobriety of lines … .' Shot by Horst the dresses are both modern and timeless and could be worn this very evening. The issue draws attention to the designer's ability to 'refresh the imagination' for designs for *le petit diner et le petit soir*.

'Givenchy always comes through for his fans,
discreetly and luxuriously. He bares shoulders,
he ruffles necklines, he puts ruffles around at the
wrist, he does black, he does colour, he does
wonderful little foulard prints … and he adds just
enough spice to keep everyone happy.'

VOGUE

'MY HERITAGE IS TO HAVE ADMIRED MR BALENCIAGA.'

HUBERT DE GIVENCHY

DIVERSE INFLUENCES

A compendium of influences have been critical to Givenchy's fortunes. Friendship, women, film and theatre, art, interior decoration and more have had a direct impact on his career. Without question, the overarching creative influence is the Spanish couturier Cristóbal Balenciaga. My query put to Givenchy about what he would like his lasting legacy to be, was answered in the following way. 'My happiness is to realise my wish to do this job,' he commented,' It is a beautiful heritage and I do not need anything else.' He went on to say that his heritage was to have admired Balenciaga, whose work had guided him in his future.

One cannot understand or appreciate Givenchy without seeing him as the disciple of the Spaniard. Givenchy's observation, made in 1955, 'All my collections stylise the essence of everyday movement,' could well have been uttered by his mentor. The Frenchman has said that he 'knew nothing about couture' until he met Balenciaga in 1953, a year after opening his salon. According to fashion historian Hamish Bowles, author of *Jacqueline Kennedy: The White House Years* and American *Vogue*'s International Editor at Large, 'Givenchy's ... line blended his mentor's austere Spanish aesthetic with his own lighthearted French tastes.' Some critics have said that the older man overshadowed the young Frenchman, not a point with which the latter would have any sympathy. Yet it is hard to conceive of some of the irreverent ideas floated by the designer in his salad days finding a place in his Balenciaga-minded collections.

Givenchy fulfilled his dream of meeting Balenciaga in New York in 1953. They met at the house of Iva S. V. Patcévitch, the President of Condé Nast, through an introduction by society hostess Patricia Lopez-Willshaw. When, as has often been the case, the Frenchman is asked about sources of influences on his work, the gist of his reply is always the same: 'Mr Balenciaga.' The designer was a revelation to him, he has said. 'He never chose the facile solution.

A pod-shaped chemise dress by Givenchy in grey wool. Considered more accommodating in style than the original form, the front falls straight to a narrow skirt, the back gently balloons below the hip.

overleaf *Givenchy and Balenciaga presented on the same double page spread, as they often were, here in American Vogue. Photographed by Henry Clarke in 1957, the theme was capes. On the left, the Frenchman's: 'a beautiful filament that grows out of the dress itself'; on the right, the Spaniard's: 'a drifting white organdie'.*

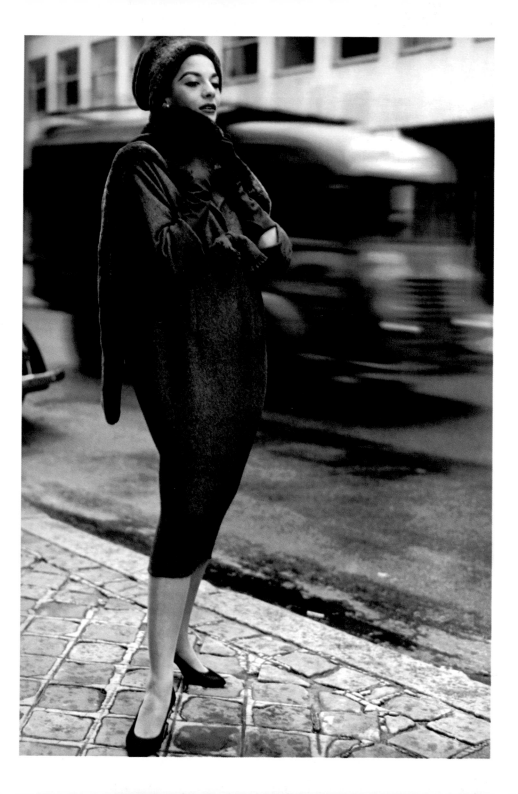

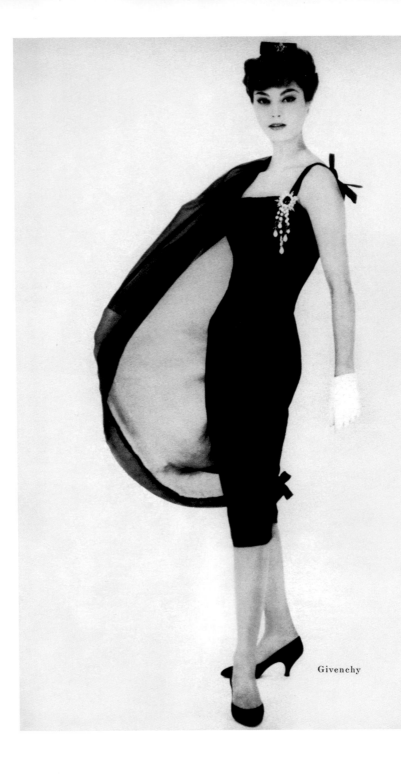

Givenchy

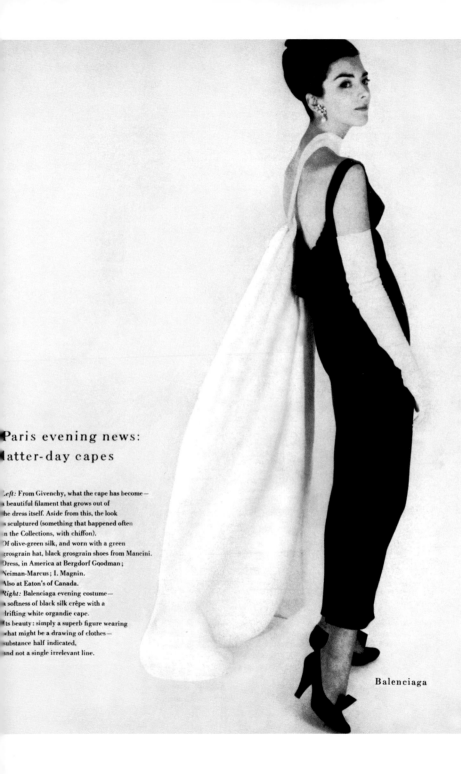

Paris evening news:
latter-day capes

Left: From Givenchy, what the cape has become—
a beautiful filament that grows out of
the dress itself. Aside from this, the look
is sculptured (something that happened often
in the Collections, with chiffon).
Of olive-green silk, and worn with a green
grosgrain hat, black grosgrain shoes from Mancini.
Dress, in America at Bergdorf Goodman;
Neiman-Marcus; I. Magnin.
Also at Eaton's of Canada.
Right: Balenciaga evening costume—
a softness of black silk crêpe with a
drifting white organdie cape.
Its beauty: simply a superb figure wearing
what might be a drawing of clothes—
substance half indicated,
and not a single irrelevant line.

Balenciaga

In one of his ensembles with just a single seam in the middle of the back, the line was so pure, so clear, it conveyed simplicity in its very perfection.' Significantly, the Spaniard imbued the younger man with his belief that style was essentially an evolutionary process. On the question of the immediate impact on a woman's wardrobe of Christian Dior's 1947 'Corolle' collection, Givenchy commented, 'The New Look was a great change in the moment but it lasted only a season. A short revolution, nonetheless, important for the image of fashion.'

With their respective salons nearly opposite each other at avenue George V, the two couturiers exchanged ideas and shared their thoughts. It was said that each was prepared to show the other their forthcoming designs. Such a closely collaborative stance between two leading couturiers working in the same highly competitive arena was unusual, to say the least. On grounds of its singularity in the domain of haute couture, and that it involved two great practitioners on a similar patch, the collaboration has been compared to that between Picasso and Braque in their Cubist period. Marie-José Lepicard, formerly of *Vogue* in Paris and New York, offers some insight into the creative relationship. 'Balenciaga liked to instruct: he was a born teacher; he had however to find a ready ear. One can imagine this Spaniard from the North with his exacting character, his pride, his simplicity of tastes, his drive for perfection, was in fact destined to meet a young Protestant raised in old family from the French provinces by an attentive and elegant mother, widowed very young. They discovered one another, Balenciaga and Givenchy became father and son … for the childless man and for the young man who had lost his father in infancy.'

The alliance between the two couturiers was made visible in *Vogue* since reviews of the designers' respective seasonal collections were published almost as a double act. Headlines sometimes consisted of simply 'B&G'. What brought this about was that in 1956, both couturiers decided to show their seasonal collections to the fashion press on dates later in the fashion calendar than those agreed by their peers.

'Tiny hats full of ideas,' said British Vogue, *making the point with a little kid toque, forward sloped, its fractured brim based on bamboo. Photograph by Henry Clarke, 1954.*

overleaf *Cecil Beaton's portrait of Audrey Hepburn styled in an 'India-pink' silk chiffon turban with a white camellia, from the couturier's India-orientated collection, 1964.*

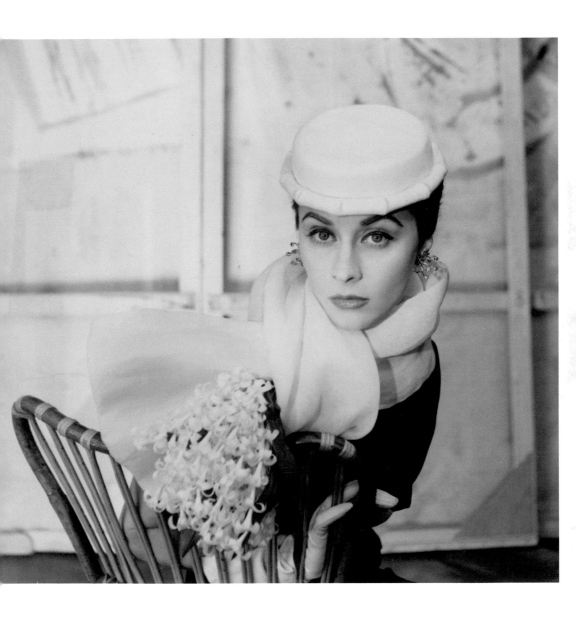

'MISS HEPBURN TOOK ONE ENRAPTURED LOOK AT GIVENCHY'S TURBANS AND TUNICS AND EXOTIC COLOURS ... AND PROMPTLY NAMED THE COLLECTION HIS "JAIPUR LOOK".'

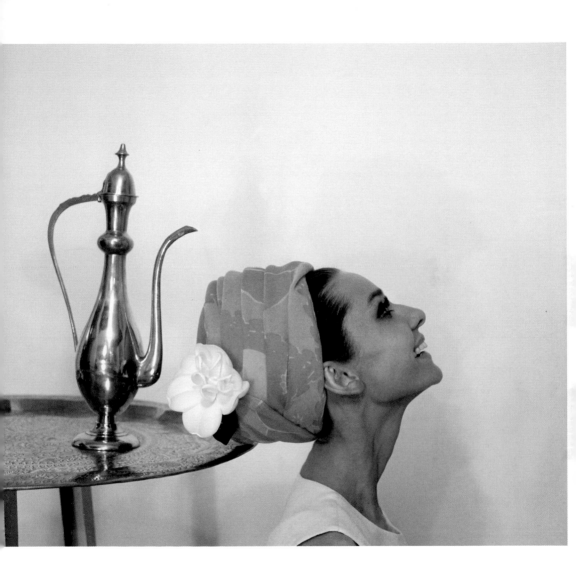

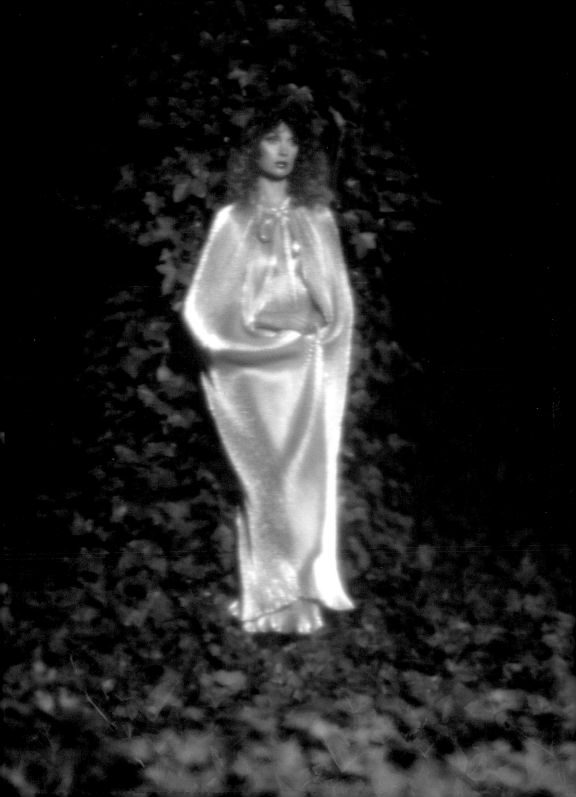

Vogue's publishing schedule did not allow the inclusion of these later shows in the issue featuring the main collections, so the two exceptions were published in tandem in a subsequent issue. A hint of the impact that the designers' decision had on the coverage of the Paris collections can be read into British *Vogue*'s Paris report in October 1958: 'There are two influential fashion houses whom one waits to see in order to get the picture clear and complete, Balenciaga and Givenchy.' The two became each other's basis of comparison. In 1962 British *Vogue* noted of Givenchy that his coat of seven-eighths length tended to be a step shorter than Balenciaga's. It also commented, 'After six, as at Balenciaga, there's a rush of black and bubbly textures, embossed velvets, matelassés, black evening suits opening on blouses in different coloured cloqués.'

Opting out of the press-show schedule suited the couturiers' purpose but the decision caused upset and inconvenience to journalists and publishers. Although the Spanish designer was notoriously press-allergic, the media had been strongly on side for the Frenchman from his early days and they felt frustrated by his action. In the autumn of 1967 the two couturiers changed course and complied with the official release dates. In 1968, Cristóbal Balenciaga closed his salon. As far as some of his important clients were concerned, the former recommended they consider Givenchy. The same applied to some of his best atelier hands including Madame Gilberte, whom Givenchy appointed as *première d'atelier*.

Givenchy developed his mentor's ideas, giving them an accent of his own. In this writer's mind at least, whereas a Balenciaga model suggests an abstract composition perfect in its sense of proportion, balance and scale in which nothing is extraneous, a Givenchy suggests a more feminised construct that places the art of couture at the altar of the woman as wearer. A good example of Givenchy's understanding of the wearer's needs, and which also follows Balenciaga's strictures on simplicity, is a jersey dress, worn by Jacqueline Kennedy as First Lady in 1961.

'GIVENCHY SEES WOMEN DELICIOUSLY.'

VOGUE

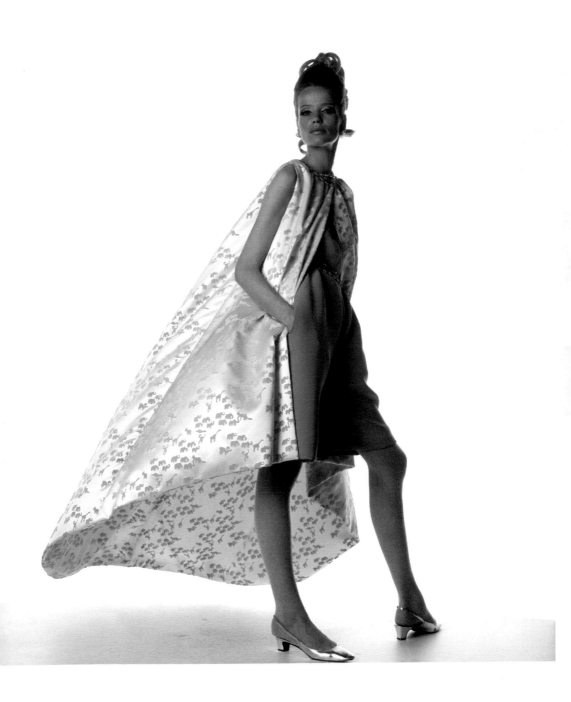

Hamish Bowles writes that it 'presented an example of haute couture illusion in what appears to be a simple wrap dress. In fact, the folds of the skirt's "wrap" hides a deep pleat.' This would have given the wearer greater ease of movement and more leg room while retaining the design's simple silhouette.

Givenchy's colour sense, rooted in Gallic art, is arguably more exuberant and decorative than is usually found in the sober palette of his mentor. A *Vogue* writer says, 'with Givenchy there is always a springtime of happy colours.' In the 1970s his faux gipsy style, which was then in fashion, called for primary shades. '*My* gipsy,' he emphasised, 'the well-dressed bohemian. The luxurious gipsy.' Givenchy's designs were of a scale that sat happily on many different types and sizes of female figures. One did not need to be thought tall to be the ideal wearer, for example. Glamour too is in his gift. Some of his evening models are of the essence.

He reinterpreted the Spaniard's controversial 1950s 'chemise' design that masked the natural waistline. Givenchy himself had produced a chemise in the autumn/winter collection of 1955, square shouldered and waistless. His grey wool chemise, done in 1957, became acknowledged as an inspired adaptation of the original form. It's a graceful pod on a stem, bloused at the back to below the hip, keeping a flat front and narrowing sharply towards the mid-calf. Another chemise of his which gained popularity has a wide bateau neckline and a body that widens just below the shoulders and tapers towards the hemline, creating an egg shape. In one such form, drawn by René Gruau (shown on page 150), the fall of folds of fabric in the front is gathered at a point just above the knee and tied in a bow. He worked on Balenciaga's hemline that gave a dancing movement to the skirt of evening clothes. The line was cut to be lifted in front and showed an ankle or more and to dip at the back, the degree of lift in relation to the dip depending on the purpose of the piece and its overall design.

Baby-doll dress in china-blue featherweight shantung, tied at the shoulders like a toddler's, photographed by Henry Clarke in 1958. British Vogue said, 'Givenchy loves to gather fullness to a yoke and let it fly free.'

previous page Givenchy's take on a shorts dress in violet silk crêpe and a coat of white satin printed in toy wild game creatures. Sleeveless, collarless, with a hemline lifted in front and dipping at the back, the coat floats into a cone shape. Photograph by Irving Penn, 1967.

Balenciaga's cone silhouette inspired some of Givenchy's prettiest evening outfits in *Vogue*, since it made use of the cape shape; the puffed out form often encompassing a fitted dress like a leaf protecting a flower bud. One such model in the 1967 collection, had a cone-influenced sleeveless coat in cut velvet printed in a motif of toy elephants and giraffes which ballooned over a violet shorts dress. Another reworking of a Balenciaga design is that of a long evening dress with, as its basic shape, three tiers: a bare-shouldered bodice sashed at the waist and a fitted skirt tied at knee level above a froth of lace or chiffon.

From the chemise morphed baby-doll, with Givenchy's version sometimes ending well above the knee, other times drifting towards the ankle. It was often made in layers of lace that could hide the contours of the body or not, depending on the transparency of the fabric used and the underpinning. Gentling the line of the Balenciaga 'barrel'-shaped skirt, he made it in glorious fabrics such as a combination of ruched taffeta and velvet. Not every critic admired this shape which was banded at the top and narrowed at the hemline, 'These skirts were so difficult to iron that they died a natural death after two or three years,' writes a British fashion historian. Givenchy eased the line of the Spaniard's balloon shape for coats and recast the notion of the sheath dress which skimmed the body decorously.

Like his mentor Givenchy worked on stand-away designs which made the most of space between the fabric and the human frame. Funnel collars on coats and jackets and dresses are a case in point, a vertical design which spaciously encircles the neck and adds a grace note to the carriage of a head. Also in this category is a carapace of fabric that appears to float above a fitted under-body – many examples appear in baby-doll form. Pouch-back jackets, semi-fitted suits in which the jacket has a swinging back and a fitted front indicating the waist, nine-tenths and seven-eighths lengths for coats, are among Givenchy's designs that owe much of their inspiration to his mentor but that in execution bear the Frenchman's mark.

British Vogue *offered a pattern in denim for Givenchy's 'Vamp dress redesigned' featuring a version of his funnel collar and his wide-set shoulder line. Photograph by Patrick Demarchelier, 1991.*

overleaf *Combining the modernism of Fernand Léger, at a retrospective of the artist at the Museum of Decorative Arts, with the modernity of Givenchy's couture,* Vogue *Paris splashed a feature on the designer's funnel collar from his couture collection. The high-rise cut works as a demi-mask – it encircles the neck and lower part of the wearer's visage yet stands at a distance from the body. Photograph by Horst, 1956.*

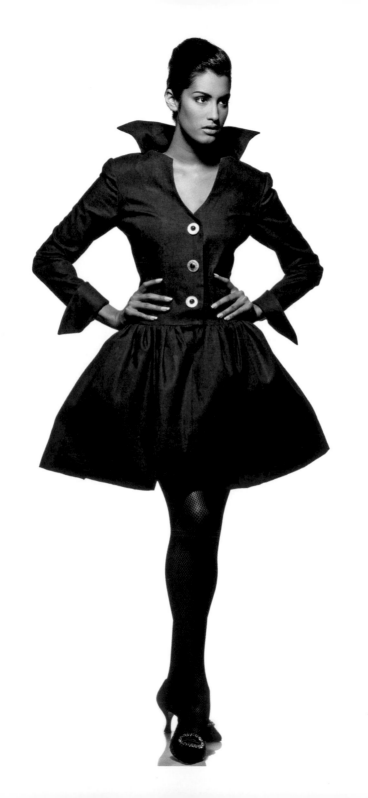

'THE VANGUARD MAN OF CONTEMPORARY CHIC.'

VOGUE

In addition, Givenchy was influenced by Balenciaga's approach to armhole design, a technique which fitted in with his own preoccupation with the comfort of the wearer. The mounting of a sleeve is known to have been a main concern for couturiers of the Balenciaga school. A wider shoulder line not only gives the impression that one is at ease in one's clothes but, in action, is easier on the body. Marie-José Lepicard describes the process: 'In a faultless envelope, which like skin, neither creases nor binds, the armhole must allow the shoulder blade, the shoulder, the collar bone, the arm to move easily so that the fabric may follow, without becoming cumbersome when the body is in repose.' Sleeves cut in one with the body of the coat or jacket, such as wide raglan sleeves with the armhole extending from the neck, and dolman sleeves that narrowed at the cuff, were among Givenchy's interpretations of Balenciaga's practice.

It was the Balenciaga-influenced search for simplicity that *Vogue* had admired from Givenchy's early days. American *Vogue* in 1953 called attention to 'a calf length black jersey dinner sheath, no belt, no collar, no back, so nothing but terrific shape.' *Vogue* was all for the less-is-more approach which it associated with a shift towards an increasingly relaxed attitude to dress, a liking particularly marked in the US edition. In 1954 Givenchy's 'nonchalance' in the form of a red jersey two piece was judged to be 'The shapeliest piece of unfitting you ever saw … the simplest bodice buttoned on to the simplest skirt.' In 1957 American *Vogue* picked up on 'Possibly as understated a suit as exists in the collection … the sole detail a pompom, doing the work of a button.'

'Purifying and refining are Givenchy's thing.'

VOGUE

Allowing for the Spanish master's pole-star guidance, there is much else of a secular nature that shaped his progress. It seems appropriate to say that since the day when Madame Bouilloux-Lafont helped to facilitate the launch of his salon, Givenchy's career had been advanced by women, and one could say by good-looking women. He has often said that he loves beauty. *Vogue* shows him here, there and everywhere as a figure in tableaux vivants in the presence of beautiful women. They seem to be an essential component in the iconography of his label, with Jacqueline Kennedy in her role as First Lady, and Audrey Hepburn as Muse, having pride of place. More generally, a preference that set him apart in this respect from many of his fellow couturiers in Paris was his decision to show his designs on exceptionally good-looking models. Bettina of the blouse being the first outstanding example, as was Jacky, one of his house models and an Audrey Hepburn look-alike. His ethnic models kept up the standard; in the 1980's many were black. China, also his house model, was effective in fashion photography. 'The models are spectacularly beautiful and young … many have become famous through films or marriage,' says the author of the Fashion Institute of Technology retrospective catalogue.

overleaf Princess (Lee) Radziwill (née Bouvier) lunching in London at the Ritz, photographed by Henry Clarke in 1960. She wears Givenchy's raw-silk suit and hat, and is holding her pug, Thomas.

Givenchy's approach to the creative force of female beauty may have had an effect on his clientele, for his label attracted an extraordinary number of famously good-looking women. And not only beauties; strong personalities across a wide generational span who knew their fashion found a home at his salon. A *Vogue Paris* writer stated unequivocally that Givenchy possessed a clientele that was 'the most *choyer* (or pampered), and most sophisticated in the world'. Whether or not that was so, it is certain that some of the most fashionable of beauties and most elegant of young women liked to see themselves in Givenchy. *Vogue* snapped up the story and invited selected private clients to be photographed for publication. These vignettes made public a private taste for his collections that flourished among the discerning younger generation.

'MANY OF THE WORLD'S MOST SOPHISTICATED WOMEN HAVE BEEN DRESSED BY GIVENCHY.'

VOGUE

The couturier's collections and the private lives of his private clients fitted neatly, and led to the match being explored in 'clothes-life' features. An instance is a piece in American *Vogue* in 1960 on Princess Radziwill, the former Lee Bouvier, sister of Jacqueline Kennedy. She is photographed by Henry Clarke at the eighteenth-century house which is her London base. The text explains that for most of her city-and-travel life, Princess Radziwill wears Givenchy clothes as they are adaptable to changing situations and climates. She has a collection of his dress and jacket ensembles, in various colours and fabrics, wears them indoors with jackets (as suits in fact) in London and Paris, and without the jackets in New York and Washington and other citadels of central heating. The text states: 'If she has a fashion signature it is simplicity.' On another subject, Lee Radziwill is said to have kept her sister well briefed on Givenchy's collections.

Baroness Thyssen wears a suit by Givenchy, the bright lemon shade, stand-away collar, wide fit of the shoulders and three-quarter-length sleeves all pointers to his current style. Photograph by Bert Stern, 1964.

In a feature headlined 'Who Buys What in Paris' in 1962, American *Vogue* featured Mrs Frederick Eberstadt, an author and the daughter of Ogden Nash, the American writer of light verse. Isabel Eberstadt is photographed by her husband Frederick Eberstadt, in five different Givenchy outfits during the course of her visit to various landmark Parisian locations, including the designer's salon. At the Tuileries, accompanied by the Eberstadt's toddler daughter Fernanda, she wears 'one of Givenchy's great coat successes in cinnamon wool, ingeniously cut and seamed to appear narrower than it is.' The story relates that her favourite short evening look by the couturier is a black cape shaped, 'exactly like an Arp egg,' she says, in a reference to Jean Arp, the artist. The cape, fastened by a drawstring, is embroidered all over with stiffened lace flowers. With it, she says, she wears a slim bare dress of black cloqué.

All three editions focused on the 'International beauties, Mrs Patrick Guinness and Baroness Thyssen' in a shoot by Bert Stern in 1964. British *Vogue* writes of them as young contemporaries of the couturier who 'follow his every designing whim'. They are dressed in Givenchy's latest ideas on long for evening, on day clothes and his decorative hats.

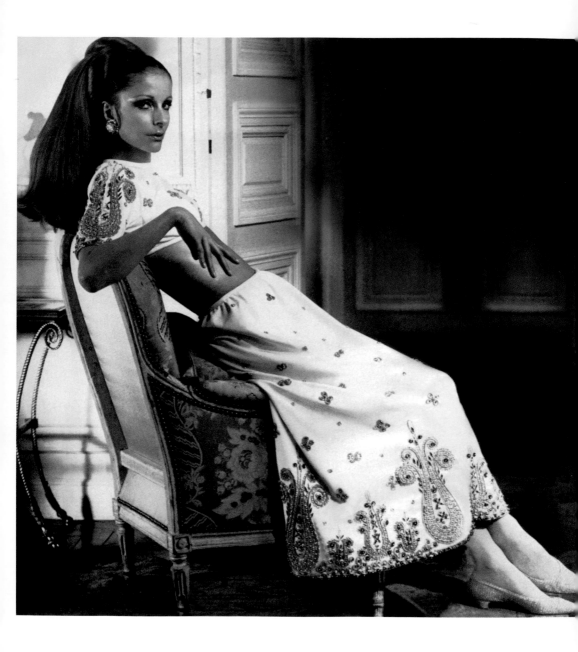

'SOME OF THE MOST BEAUTIFUL LOOKS IN PARIS ARE FROM A COLLECTION WHICH FOUND GREAT NEW PROPORTIONS FOR BELOW-THE-KNEE SKIRTS.'

VOGUE

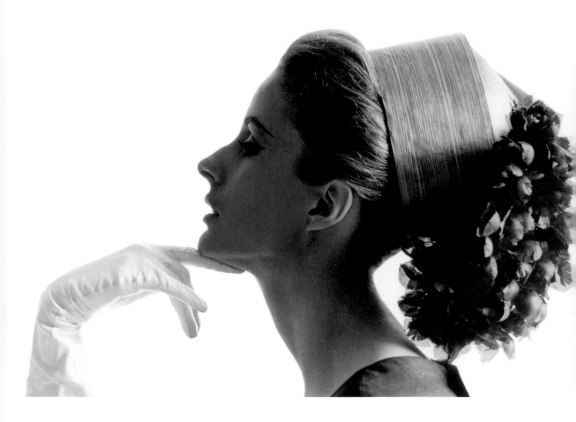

Mrs Patrick Guinness in profile, domed by
Givenchy's cache chignon, worn far back, with
black organza petals afloat from the crown.
Photograph by Bert Stern, 1964.

previous page Baring her midriff, Mrs Guinness
wears Givenchy's small white bodice and skirt
made in silk with Indian-influenced motifs
sewn in gold embroidery by Lesage. Photograph
by Henry Clarke, 1970.

Dolores Guinness, whose mother Gloria Guinness also was a Givenchy client, is shot in close-up, her classical profile domed in a cache chignon which has 'black organza petals afloat from the crown' worn far back on the head. In American *Vogue*, she is styled to herald 'the return of the strapless evening dress at Givenchy.'

The Baroness is the former fashion model Fiona Campbell-Walter who married Baron Hans Thyssen-Bornemisza, the industrialist and art collector. Her outfit is said to illustrate current aspects of the designer's work; a love of bright colour – the suit in question is in lemon yellow – a liking for off-centre fastening shown in the tailored jacket, and belief in a narrow tie belt at the waist. The jacket rests on a lightly barrelled skirt.

Also photographed in profile, Fiona Thyssen sports a swathed turban of yellow and blue tie silk. In American *Vogue* she is also portrayed wearing 'a great beauty's dress ... a strapless organza princesse in tones of turquoise and India pink.' *Vogue Paris* introduced the sitters as 'his most fidele – faithful – clients', running the pictures of them in evening clothes, day dress and cache chignons.

Along with the patronage of the younger generation of socialites, Givenchy had a large constituency among actors and performers. They responded to him as an artist who understood their business and was a player in it. He did the costume designs for sixteen films and also designed for the stage. One production was the film of Françoise Sagan's novel, *Bonjour Tristesse*, a story set on the Riviera. In 1958, American *Vogue* photographed the stars of the film, Deborah Kerr and David Niven, in character and in costume. The former, a Givenchy client in private life, wears one of Givenchy's chemises. It's a summery off-duty number, hemline below the knee, big pockets at the hip, and the designer's known stand-away-stand-up collar. The magazine suggests that the costume might represent a moment in cinematic history – a first sighting of the waist-less chemise on the big screen.

A retrospective catalogue published a roll-call of well-known performers that included the following names, reproduced here at random: Leslie Caron, dressed by him in private life as well as on stage for the play *Orvet* in 1955; Gloria Swanson, a private client, wore a chemise; Jean Seberg chose an outfit by him for a gala at the Paris opera; Sophia Loren has declared she wears him virtually to the exclusion of all others; Lauren Bacall was dressed in the designer's black lace for the New York premiere of *Othello*; and Elizabeth Taylor was photographed off duty in a pale pink kaftan from a Givenchy boutique. Also among other performers who appeared in public wearing his label were Marlene Dietrich, Merle Oberon, Greta Garbo, Maria Callas, Romy Schneider, Julie Christie, Jennifer Jones, Diana Ross, Juliette Greco and Capucine, the last named still dressed by him in the 1990s. One well-known American opera singer, mezzo-soprano Frederica von Stade has on record that, when she wears a Givenchy, 'I sing better.'

Deborah Kerr and David Niven in costume and in character for the film Bonjour Tristesse. *Givenchy did the costumes for both stars; the leading lady is shown in one of his Fifties chemise dresses. Photograph by Elia Kazan, 1958.*

Diana Vreeland, the former editor in chief of American *Vogue* merits a special mention. In 1986 the couturier dedicated his spring/summer collection to her, the evening looks taking their cue from the 'Costumes of Royal India' exhibition organised by Mrs Vreeland in her role as Special Consultant and inspiratrix at The Costume Institute, Metropolitan Museum of Art. Givenchy puts in a cameo appearance in the film *The Eye Has to Travel*, a biographical odyssey through Diana Vreeland's experiences inside and outside of *Vogue*. In it he says 'She was more than an editor. She was the creator of fashion. She saw things in a totally different way.' A small instance of this occurred in connection with the couturier when Mrs Vreeland was at *Vogue* in the late 1960s. It was to do with a new cosmetic from his company, a leg paint. Her biographer writes, 'She was 'intensely annoyed by the lack of editorial interest in the idea. She said, "I think it is curious that none of you have taken up with this coloured paint because it is very amusing and projects a mood." '

The coverage of Givenchy at home, in the pages of *Vogue*, opened up another side to him. The stories emphasised the interaction of fashion, art and interior decoration in his pursuits. In 1969 American *Vogue*'s 'Life-style Givenchy' article illustrates the manner in which, in interior decoration as in fashion, the designer sets old against new. At his Paris apartment on the Left Bank, Picasso's recent oil, 'Man with a Pipe' dated 1968, is hung above a Louis XVI console, a piece described as being 'carved with lions' heads, hides and lashing tails'. Givenchy himself is photographed beside a Picasso drawing, 'Great Pan', dressed for evening in an outfit from his forthcoming menswear collection – silvered brocade trousers partnered with a navy silk turtleneck. The story moves to his then country house, the setting for a shoot of the designer in which both the pose he adopts of stretching out his length on a sofa and the wardrobe in which he is styled are reminiscent of a well-known portrait of an English officer by the nineteenth-century French artist James Tissot. Guardsmen's black trousers with a narrow red stripe down one side are strapped over black patent boots, an outfit styled with a black silk pullover.

The designer, photographed at home in the country by John Cowan in 1969, models an outfit from his forthcoming menswear collection. Guardsmen's black trousers with a narrow red stripe are styled with a black silk pullover.

'In his Paris apartment, his house near Versailles, the clothes he designs – and wears – Hubert de Givenchy proves out his sense of proportion, of edited luxury, of the balance of present and past.'

VOGUE

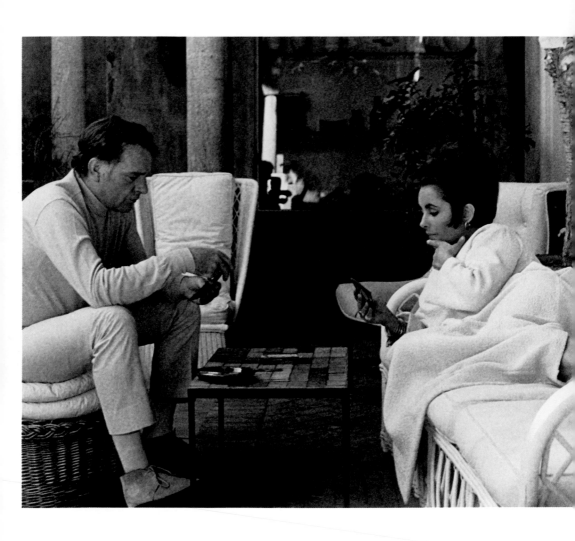

A similar approach but with an emphasis on his couture collection appeared in British *Vogue* in 1974. The Paris location is the same and the works of art, the décor and ambiance leads the writer to say, 'the setting is superb and so is Givenchy'. Norman Parkinson photographs the couturier as he found him: barefoot, dressed informally in an open neck pale blue shirt and Prussian blue trousers. He is seated and has a friendly arm round the model who is caught laughing as she stands beside him. She is styled in a graceful, full length shift slit from thigh to ankle in an exquisite oriental silk print of flower emblems.

The print is by Abraham. With a bateau neckline, the full wide sleeves spill into silken fringes that touch the ground. Interviewed, the designer advances the cause of his metier, saying, 'Haute Couture is an investment because it doesn't simply last for a season ... it goes on and on. The dress is a classic example of what I mean. It has lots of detail with its fringes and its movements in the sleeves, yet there is nothing to date it.'

A new perspective on Givenchy's heartfelt values emerges in American *Vogue*'s coverage of his acquisition of Le Jonchet, a sixteenth-century moated manor house in the Touraine, not far from Paris. 'Paradise ... but on a scale for living,' he says. Although he had acquired the property in 1976, the story was published several years later and concerns work in progress both at the house and in the landscaping. Details suggest a consistency to his taste. An eighteenth-century Chinese wallpaper depicting 'The Mandarin's Marriage' is hung in the dining room. A guest bedroom is done in a single cotton print. His mother, as he says in the text, liked to make a show of a fabric in a room. In his case, he splashes out with the 'The Tree of Life', a cotton print depicting flowers, foliage and arboreal forms that decorate bed, canopy, walls and chairs. On view in the studio, yet to be fully furnished, is a Miro. Also shown in progress is a landscape design in which young box planted in curlicues, swirls over the parterre. The owner, photographed seated in the forecourt with the architecture of the manor in the background, tells the magazine, 'For me, this epitomises "la belle France".'

'HAUTE COUTURE IS AN INVESTMENT BECAUSE IT DOESN'T SIMPLY LAST FOR A SEASON ... THERE IS NOTHING TO DATE IT.'

HUBERT DE GIVENCHY

'I FOLLOWED A DREAM.'

HUBERT DE GIVENCHY

TRIUMPHS
AND REVERSES

Honours, awards and homages followed in Givenchy's wake from the end of the Sixties throughout the succeeding years of his public life. Among them, he was awarded the coveted Gold Thimble by his contemporaries in 1978, named 'Personality of the Year 1979' for his activities in haute couture, voted one of the Best Dressed men in the world in 1980, and made Chevalier de la Legion d' Honneur in 1983.

Vogue Paris added to the accolades by publishing in 1987 a story headlined, 'Givenchy opens the doors of his private museum for the first time'. A portfolio by Snowdon of the interiors at the designer's eighteenth-century house at the rue de Grenelle unveils a collection of Boulle furniture, bronzes and art works in an architectural setting of classic French elegance. 'I followed a dream of buying furniture from the seventeenth and eighteenth centuries and contemporary art,' the designer said in an interview in the arts magazine *Apollo*. 'I bought slowly, buying the best I could afford and never asked an expert's opinion.' What he did do as a young man, he explained, was to train his eye by familiarising himself with the interiors and furniture of the living great collectors. He had slowly come to be received by them. 'I looked and I looked and I saw every style and tradition and I realised what I did not like and what I did like.'

At the grand salon which has its original gilded *boiseries* (panelling) in place, things reflect his stated intentions, 'I try to find associations between objects that seem natural.' To judge from the pictures, arrangements of furniture and objets d'art convey, within the formal style, an atmosphere of sociable comfort. Among the pieces highlighted in the story are a spectacular Boulle armoire, a Louis XIV cabinet in ebony, brass and tortoiseshell embellished in gilt bronze and made by Etienne Levasseur, one of the leading cabinet makers of the time, and a school of Bronzino study of a young man, a Mannerist painting, which is photographed reflected in a gilded framed mirror. The modern is represented in a tapestry chair covering done in the

Givenchy with one of his acquisitions, a Louis XIV pilaster, at his Paris house on the Left Bank, 1987. From a Vogue Paris portfolio by Snowdon focusing on the couturier's previously unpublished collection of Boulle furniture, paintings, and objets d'art.

manner of drawings by Braque. Some objects of special personal sentiment find a place in the story such the flowered embroidery in which a chair was upholstered, the sewing having once belonged to the couturier's mother, and the designer's small teddy 'Hubear' dressed up in a version of the designer's white coat (it is said the original was given him by Balenciaga). Givenchy is photographed at the entrance of the house, looking jolly pleased, it has to be said, standing beside a Louis XIV Boulle pilaster on the top of which one of his two pet canines, Windy, poses for the camera.

The following year he dedicated the spring/summer couture collection to Audrey Hepburn; one of the designs a mini dress composed entirely of poppy petals. It was the year when the star began what was to be her last official commitment before her death in 1993, working to support the charity Unicef, and Givenchy continued to advise her on clothes for her public fund-raising appearances. In November 1988 he sold the couture house to LVMH (Louis Vuitton Moet Hennessy) the multinational luxury goods conglomerate. His response to my question about whether he had had enough of the couture world and might have run out of creative energy was a firm denial.

'Givenchy was a Protestant schooled in the same work ethic as Audrey. It made for a closeness between them that went far beyond the usual relationship of couturier and client.
It was a platonic love affair.'

ALEXANDER WALKER

'PERFECTION IS
NOT HERE IN THIS
BEAUTIFULLY MADE
DRESS WORN SO WELL
BY THE MANNEQUIN.
PERFECTION IS THE
DRESS AS IT WILL BE
MADE FOR A CLIENT
WHO WILL WEAR THE
DRESS DIFFERENTLY.'

HUBERT DE GIVENCHY

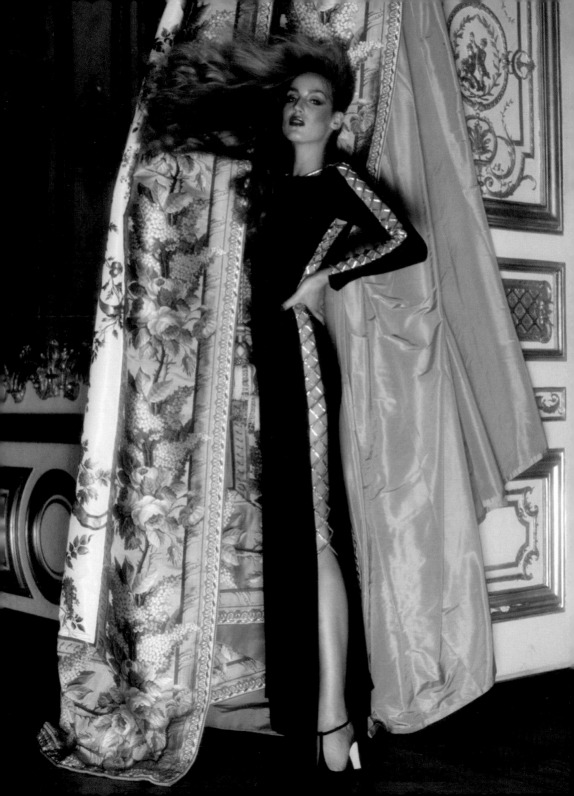

'TONIGHT MADAME, YOU ARE LOOKING LIKE A WATTEAU.'

GENERAL DE GAULLE

Jacqueline Kennedy in the line-up on the balcony at the dinner in honour of the Kennedys, at the Palace of Versailles, June, 1961. Her embroidered Princesse dress was specially created for the occasion by Givenchy.

'It is not at all that I wanted to get out of fashion,' he commented. 'As Mr Recamier, the owner of the LVMH group was interested in the whole affair, it seemed reasonable to link fully with this important group that could bring greater development to Givenchy Haute Couture, prêt-à-porter and perfumes.' A new scent, Amarige, and further investment in the business, followed on the sale.

A seal was set on his reputation at the 'Givenchy: 40 Years of Creation' retrospective at the Musée Galliera, Fashion Museum of the City of Paris, in 1991. In the book of the exhibition, *Vogue's* stable of photographers are among those called on for references that memorialise the couturier. Some of his outstanding designs, such as the chemise, little black dresses, shorts outfits, capes and evening décolletés are reproduced in photographs by leading practitioners, among whom are David Bailey, Henry Clarke, William Klein, Norman Parkinson, Irving Penn and Bert Stern; employing his bold poster-like black brush strokes, René Gruau brings The Bettina blouse back to life on the cover. Former *Vogue* editors and the Curator-in-Chief of the museum contribute to the text. Among the named models are Bettina, Capucine, Jerry Hall, Suzy Parker and Jacky. Pictures of the façade of Le Jonchet and illustrations of the interior bear witness to his other creative pursuits reflected in *Vogue*. A leitmotif in the pages is Audrey Hepburn, depicted both in character in film roles and as the couturier's fashion model. As herself she contributes a poem to her friend, in which she reflects on his capacity for friendship, humour, warmth and generosity. The eulogy also contains the following lines:

'Hubert has not perhaps …
All that he loves but he loves all that he has.'

Givenchy's work-life experience whisked through in this narrative might read as an onward and upward progression. But the following public setbacks, the details of which were beyond the brief of *Vogue*, are very much part of his history too. In 1954, the screen credit that was rightfully his for the costumes he had done for Audrey Hepburn in the Billy Wilder film *Sabrina*, eluded him. Edith Head, ruling hand of Costume Design at Paramount, accepted the Oscar

for Best Costume Design and in her acceptance speech did not thank or acknowledge Givenchy. Jay Jorgensen, Edith Head's biographer writes, 'It is hard to say how much of this may have been influenced by sheer studio politics and her desire to maintain her position.' Two of the costumes have become virtual emblems of the movie. One, a film-starry white ball dress patterned in fantasy flowers, takes the form of a bustier, a sheath skirt cut to ankle length and a style-defining bouffant overskirt, side draped and flowing over a bustle into a train. However, it is the other costume in the case, a black cocktail dress, that was at the centre of the brouhaha. The design had been conceived to meet the star's special needs. A small bow perched at each shoulder and a kindly boat neckline masked what Hepburn was sensitive about, the hollows behind her collarbone. It became known both as The Sabrina Dress and The Sabrina Décolleté and was copied a thousand times over by dress manufacturers, and as an image has been reproduced beyond count. Only after Edith Head's death did Givenchy confirm that the black dress was his original design and had been made under

overleaf Audrey Hepburn depicted in character as Sabrina, the film in which she plays the title role, here dressed by Givenchy.

Head's supervision at Paramount. At the time, Givenchy had had no contract with the film company. As the timing of the misattribution was only two years after he launched his salon, some support at that stage would have been welcome.

It was headline news in the US in 1961 when Jacqueline Kennedy, a private client who had added great lustre to his label, announced that as First Lady, she would no longer wear French clothes. According to biographer Sarah Bradford, Kennedy's 'favourite designers were of course, Givenchy and Balenciaga … she had known Hubert de Givenchy since 1952 and had been a client since her marriage … the Givenchy look, spare sleeveless A-line dresses as worn by Audrey Hepburn … was the one that most appealed to her.' Objections to her preference for European designers for her wardrobe had been raised forcefully in the American press. The pronouncement quietened the outcry but some leading journalists remained sceptical. Latter-day accounts suggest that Jacqueline Kennedy found ways and means of keeping alive a link with Givenchy's collections, but under cover wasn't the same as above board.

'AUDREY WORE
CLOTHES WITH
SUCH FLAIR ...
HER CHIC AND
HER SILHOUETTE
GREW EVER MORE
CELEBRATED,
WRAPPING ME
IN A RADIANCE
I COULD NEVER HAVE
HOPED FOR.'

HUBERT DE GIVENCHY

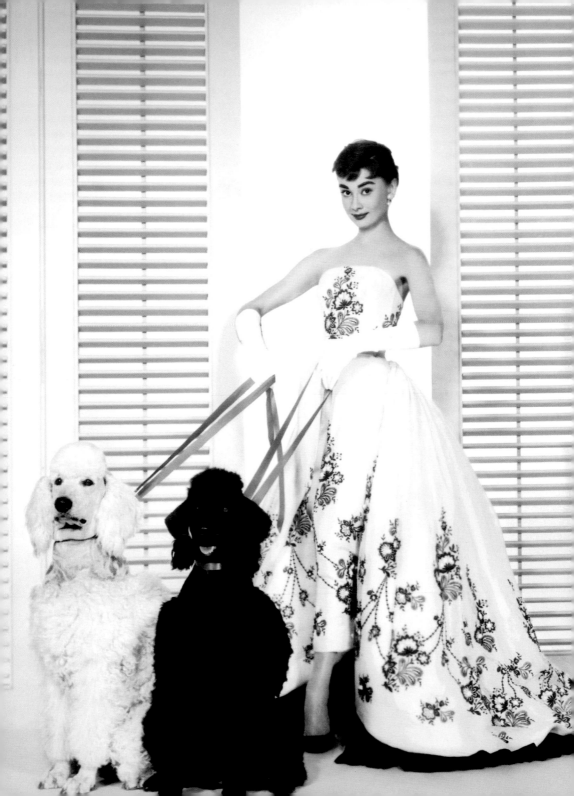

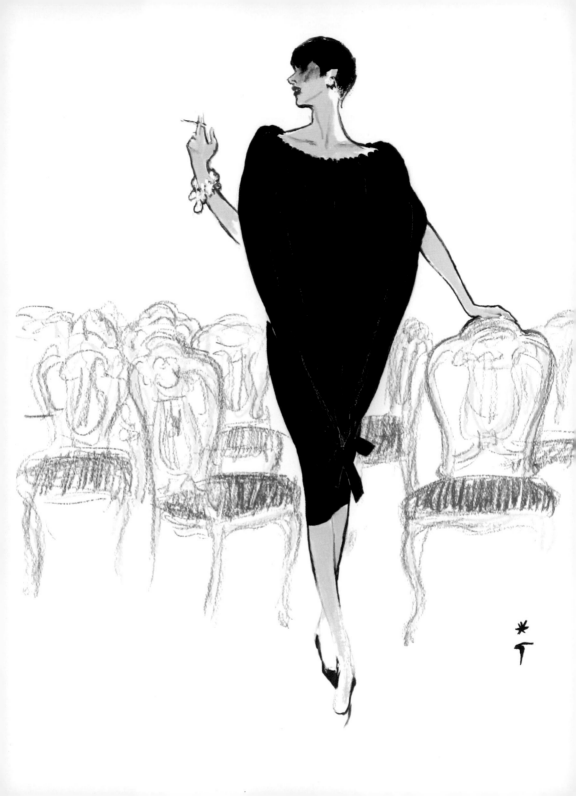

However, there was a temporary dispensation to the embargo in the same year that it was imposed, prompted by the Kennedys' forthcoming diplomatic visit to France. Jacqueline Kennedy was to be allowed to wear Givenchy officially as a compliment to her hosts. Even so, Givenchy has told that the news that she was wearing designs by the French house had to be kept a secret until the last hour. According to Bradford, he had been instructed by a third party to prepare a wardrobe for the trip. He made her a pink coat and a pink dress in wool and a long evening dress and opera coat for the important dinner at the Palace of Versailles honouring the Kennedys. The evening dress was chosen by Lee Radziwill and adapted in Paris so that the piece was unique; the effect conveyed a picture of youth and glamour while indicating her loyalty to historic French culture. In ivory silk zibeline, the sleeveless fitted bodice was strewn with embroidered flowers – lily of the valley and open roses – a reminder of her love of the eighteenth-century decorative arts of France. Jacqueline Kennedy told the designer that General de Gaulle had said, 'Tonight Madame, you are looking like a Watteau,' a reference to the picturesque costumes in the eighteenth-century French artist's paintings. In the formal photographs of Jacqueline Kennedy in the balcony line-up at Versailles, published in *Vogue*, it's not overstating it to say she stands out like a fairy queen among the penguins in white tie.

René Gruau's retrospective drawing of a sac (chemise) in wool crêpe, from Givenchy's 1955 collection, published in homage to the couturier in Vogue Paris, *1995. 'One of the fathers of Parisian elegance' it said.*

The founder formally stood down from the House of Givenchy in September 1995. At his final collection, the designer bid farewell wearing his sacred white coat. He went out on a teasing remark telling his audience that he had produced an elegant collection that ensured that his 'loyal older customers wouldn't be left with nothing to wear.' Nevertheless, *L'Oeil de Vogue* records a tearful occasion attended by his peers and private clients. *Vogue Paris* also marked the moment in July 1995 with a big spread on the couturier, publishing René Gruau drawings of outstanding designs from past collections.

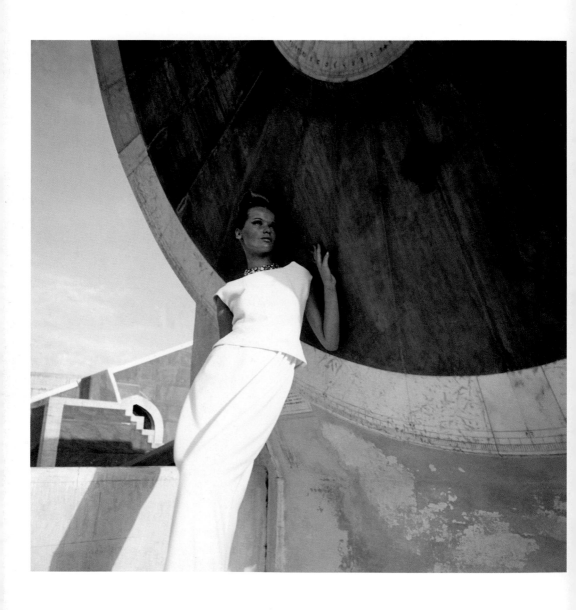

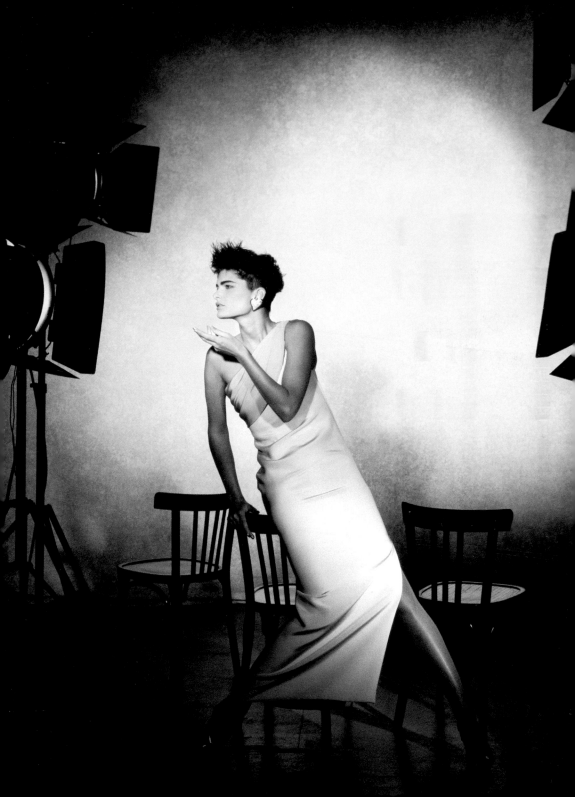

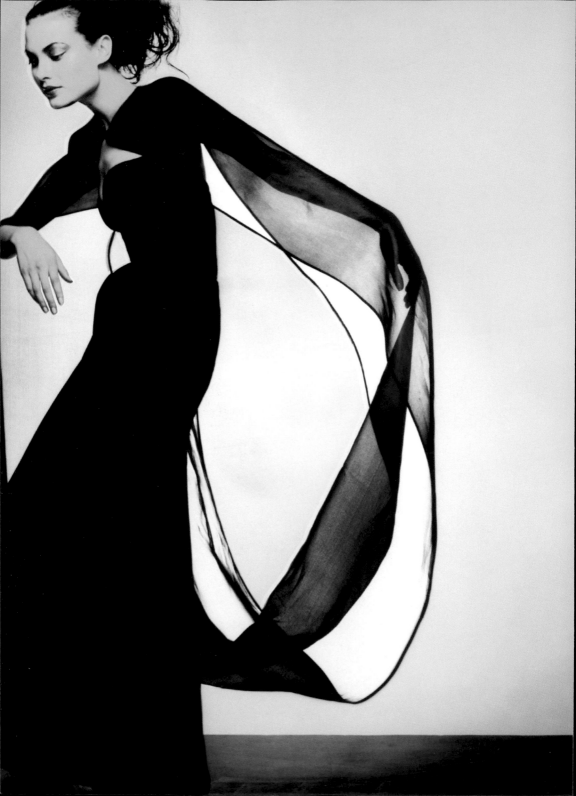

Drawn retrospectively were: an evening dress in black moiré, immensely full skirted, with a hemline below the knee, neatly waisted with a deep décolleté framed in a bertha collar, from the 1953 collection; a 'sac' (chemise) in black wool crêpe, from 1955; and a model from his final show, a full-length evening sheath in a bi-colour silk crêpe, the pattern vertically bisected in black and white and decorated at the waist with the loops of a faux bow embroidered in gilded sequins. A Gruau full-length sketch of Givenchy accompanies the illustrations.

British *Vogue*'s final shot of a Hubert de Givenchy design was taken by Nick Knight; it is a sculpted evening dress of black velvet made with an airy organza cape. It well reflected the creator's views on the timelessness of his couture, having affinities to a model done in the mid-Fifties. When I questioned the designer about the future of his metier, he replied thus: 'The real Haute Couture as I knew it is over. What will replace it I do not know. But the change is there. It's obvious that new designers will find a style for that future change. If I had to redo Haute Couture it would be for luxury ready-to-wear… but for this you need a very strong organisation that is well directed.'

Looking back, he can know that his childhood dream of becoming an haute couturier was realised, that in his work he had respected the principles of his mentor Balenciaga, that his designs had made many a woman happier with herself. He can also reflect that through his own best efforts he had come to be regarded as an arbiter of elegance and style in the gilded years of Paris couture. It seems in order to speculate on the secret of his creativity. When he visited the Oxford University Union to give a talk to students in 2010 he demonstrated a kind of answer. 'You are like a butterfly, in every moment you must have good reception,' he said, miming lively antennae, 'in every moment you must pay attention and notice.' His 'eye view' mentioned at the opening of my account, served him well.

Index

Page numbers in *italic* refer to illustrations

References

America's Queen: The Life of Jacqueline Kennedy Onassis by Sarah Bradford, Penguin Books, 2001

Audrey: Her Real Story by Alexander Walker, Weidenfeld & Nicolson, 1994

Cristóbal Balenciaga: The Making of a Master (1895-1936) by Miren Arzalluz, V&A Publishing, 2011

Edith Head: The Fifty-Year Career of Hollywood's Greatest Costume Designer by Jay Jorgensen, Running Press, 2010

Empress of Fashion: Diana Vreeland by Amanda Mackenzie Stuart, Harper, 2012

Givenchy: Forty Years of Creation by Catherine Join-Diéterle, Paris-Musées, 1991

Givenchy: Thirty Years by Robert Riley, 1979

Hollywood Costume by Deborah Nadoolman Landis, V&A Publishing,

Jacqueline Kennedy: The White House Years by Hamish Bowles, Bulfinch, 2001

Paris à la Mode: A Voyage of Discovery by Célia Bertin, Victor Gollancz, 1956

Paris After the Liberation 1944-1949 by Antony Beevor and Artemis Cooper, Penguin Books, 2004

The Golden Age of Couture: Paris and London 1947-57, edited by Claire Wilcox, V&A Publishing, 2008

The Restless Years: 1955-63 by Cecil Beaton, Weidenfeld & Nicolson, 1976

Picture credits

Author's acknowledgements:
I am indebted to M. Hubert de Givenchy for his courteous replies to my questions.
My special thanks are also due to Sarah Mitchell, my editor at Quadrille and to Brett
Croft, Condé Nast's archive manager, for their patience and forbearance in the light of
my demands. Beyond the names, I would like raise a cheer for the photographers and
artists whose work has done so much to secure the memory of Hubert de Givenchy's
years in fashion.

Publishing Director Jane O'Shea
Creative Director Helen Lewis
Series Editor Sarah Mitchell
Designer Nicola Ellis
Assistant Editor Romilly Morgan
Production Director Vincent Smith
Production Controller Leonie Kellman

For *Vogue*:
Commissioning Editor Harriet Wilson
Picture Researcher Frith Carlisle

First published in 2013 by
Quadrille Publishing Limited
Alhambra House
27–31 Charing Cross Road
London WC2H 0LS
www.quadrille.co.uk

Cataloguing in Publication Data: a catalogue record for this book is available from
the British Library.

ISBN 978 1 84949 313 0

Printed in China